A BRIEF HISTORY OF
ORANGE
CALIFORNIA

— ✤ —

The Plaza City

Phil Brigandi

Charleston · London
The History Press

Published by The History Press
Charleston, SC 29403
www.historypress.net

Copyright © 2011 by Phil Brigandi
All rights reserved

Front cover, bottom: Downtown Orange in the 1920s, by local artist Harry Keltner, 1985. *Courtesy the artist.*

First published 2011

Manufactured in the United States

ISBN 978.1.60949.287.8

Library of Congress Cataloging-in-Publication Data
Brigandi, Phil, 1959-
A brief history of Orange, California : the plaza city / Phil Brigandi.
p. cm.
Includes bibliographical references and index.
ISBN 978-1-60949-287-8
1. Orange (Calif.)--History. I. Title.
F869.O6B74 2011
979.4'96--dc23
2011028515

Notice: The information in this book is true and complete to the best of our knowledge. It is offered without guarantee on the part of the author or The History Press. The author and The History Press disclaim all liability in connection with the use of this book.

All rights reserved. No part of this book may be reproduced or transmitted in any form whatsoever without prior written permission from the publisher except in the case of brief quotations embodied in critical articles and reviews.

CONTENTS

Introduction	5
1. Before We Were Orange	7
2. A Town Is Born	15
3. Boom and Bust	29
4. A Growing Community	47
5. Tract Homes and Freeways	85
Selected Bibliography	113
Index	117
About the Author	127

INTRODUCTION

The story of Orange is the story of a little town that got big—and yet still retains some of that small-town feel. Founded in 1871 and incorporated in 1888, a year before the southern end of Los Angeles County broke away to form Orange County, the city of Orange was primarily an agricultural community until the 1950s, when modern suburban development arrived.

Today, our population tops 135,000, yet many people still think of Orange as a small town. Part of that image comes from our historic downtown—not just the business buildings around the Plaza, but the blocks and blocks of historic homes surrounding it, many of them lovingly restored. The Plaza is the heart of old Orange and a symbol of our small-town origins. While other Orange County cities have swept their downtowns clean or redeveloped them into bland, beige blocks of stucco, downtown Orange still retains much of its original look and feel.

And it's the Plaza, not the Circle (as the bumper stickers around town say). The tongue-in-cheek battle between the locals and newcomers is simply a way for the hometown folks to say, "This is my town, and I care about its past." Try saying "Frisco" to a true San Franciscan and you'll get the idea.

I was born in Orange and went all through school here. I've been researching and writing its history since 1975. Over the years, I've spent countless hours reading through old newspapers and talking with old-timers. It is that combination of documentary sources and living memory that always makes for the best local history.

So many old-timers have been helpful to me over the years it is difficult to pick out just a few, but I will always fondly remember the help and support I

Introduction

received from Florence Smiley, Lena Mae Thompson, Kellar Watson, Ken Claypool, Harold Brewer, David Hart and so many others.

I am also very appreciative of the other historians who have written about the history of Orange over the years, including Wayne Gibson, Paul Clark, Jim Sleeper and most of all Don Meadows, my great mentor as a local historian.

At its best, local history shows us how we got to where we are and offers some clues of where we are going. The issues and challenges we faced in the past will often meet us again. Knowing that others found solutions in the past should give all of us hope for the future.

Chapter 1
BEFORE WE WERE ORANGE

My father claimed to be an owner of the Santiago de Santa Ana ranch. He died in the year 1829. He was a partner of the rich Yorba [José Antonio Yorba I]. I knew [his sons] José, Tomas and Teodosio Yorba. They lived near where Orange now is. Tomas used to have a vineyard and used to occupy himself in taking care of it and his crops, and his vaqueros used to look after his stock. He cultivated and irrigated corn, beans and wheat. He had a great many servants and cultivated a good deal. José Yorba [II] cultivated land in 1835 to a considerable extent. The land so cultivated was west of Orange. He raised there corn, wheat, watermelons, pumpkins and a small variety of beans. He had a great number of servants employed aiding in the cultivation. Teodosio Yorba also cultivated land in 1835 which was situated between the other two Yorbas. Tomas Yorba was next to him above, and José was located further down.
—Rafael Peralta (1816–1894), son of Juan Pablo Peralta, testifying in the water lawsuit between Orange and Anaheim, 1880

Long before California became part of the United States, the level plain south and east of the Santa Ana River was known as the Rancho Santiago de Santa Ana. Both names date back to the Portolá Expedition of 1769, the first Spanish soldiers to march overland through California.

Captain Juan Gaspar de Portolá and his men were heading north from San Diego, where California's first mission had just been founded, in search of Monterey Bay. As they crossed what is now Orange County, they gave us a number of place names that survive to this day. The Santa

Ana Mountains were named on St. Anne's Day on the Catholic calendar. Soon the name spread to take in the river that flows out of the mountains. At Trabuco Creek, one of the soldiers lost his blunderbuss gun—in Spanish, his *trabuco*.

On the evening of July 27, 1769, the expedition stopped beside another creek. It was St. James Day, so the creek became known as Santiago. Portolá and his men camped about half a mile above where Chapman Avenue now crosses the creek. The expedition's priest, Father Juan Crespí, noted in his diary:

> *We halted after three leagues of travel near an arroyo of running water. It has willows, grapevines, brambles, and other bushes. The water comes down from the mountains and shows the arroyo must have plenty of water in the rainy season…If this watering place should remain throughout the year, it would be a site for building a city on account of the large amount of land and the extensive plain that the arroyo has on both sides.*

In 1771, the Spanish founded a mission at San Gabriel. Five years later, the Mission San Juan Capistrano was founded by Father Junípero Serra. The missions were the first step in the Spanish colonization of the area, designed to convert the local Indians to Catholicism and teach them useful trades so they could become citizens of the Spanish Empire. Mission San Gabriel grazed cattle and horses all the way down to the Santa Ana River, while San Juan Capistrano's flocks grazed to the south.

Colonists were also sent north from Mexico to help found California's first pueblos. In the winter of 1775–76, Colonel Juan Bautista de Anza led the first large group of settlers across the desert to San Gabriel. One of Anza's chief lieutenants was Juan Pablo Grijalva, an experienced frontier soldier.

As the years went by, California's earliest Spanish soldiers began to retire, and a number of them decided to remain here. Cattle ranching was California's prime industry in the early days, with the hides and tallow sold to trading ships that carried them away to England and the eastern United States, so the soldiers sought land to raise their own herds.

About 1800, Juan Pablo Grijalva began running cattle along the Santiago Creek. In 1801, the commander at the presidio in San Diego gave preliminary approval for him to occupy "the place of the Arroyo de Santiago." Before long, Grijalva had built an adobe ranch house atop a small hill overlooking the creek. Today, the Hoyt house (built in 1888) covers the site, above the southeast corner of Hewes Avenue and Santiago Canyon Road.

Before We Were Orange

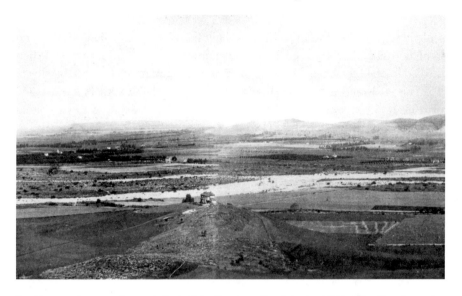

Looking north across the sandy bed of the Santiago Creek in the 1890s. The Hoyt house is clearly visible in the foreground on the little hill where Juan Pablo Grijalva built his adobe ranch house about 1800. The Hoyt house still stands, surrounded by newer homes. *Courtesy the First American Corp.*

One of the most common mistakes in California history is to speak of "Spanish land grants." Under Spanish law, all the land in California was considered the property of the King of Spain. Indians, missionaries and rancheros were simply given permission to use parts of his domain. What Grijalva received was essentially a grazing permit, and even that was only a provisional concession from the commander of the presidio at San Diego. If the governor ever formalized Grijalva's concession, that document was soon lost.

After Grijalva's death in 1806, his son-in-law, José Antonio Yorba, and grandson, Juan Pablo Peralta, took over the rancho. In 1809, they filed a new petition for use of the land here, which was approved by the governor in 1810. The vast Rancho Santiago de Santa Ana took in everything south and east of the Santa Ana River from the Santa Ana Canyon down to the sea, bounded on the southeast by a line running from Red Hill to the top of Newport Bay—marked today by the odd angle of Red Hill Avenue.

The Yorbas and Peraltas settled on different parts of the Rancho Santiago de Santa Ana. Most of the Peraltas lived up the Santa Ana Canyon, in what is now Anaheim Hills (the 1871 Ramon Peralta adobe still stands to mark the spot). Some of the Yorbas settled around the hill at Olive, at the north end of Orange. About 1825, José Antonio Yorba II moved about four miles downstream to

settle in what is now West Orange. He built his adobe home along El Camino Real, north of what is now Chapman Avenue and west of Feldner Street. When he died in 1844, he left 4,345 head of cattle, more than 300 horses, 769 sheep, two vineyards and two adobe homes to his descendants. Others later settled near his home, in what became known as Santa Ana Abajo, or Lower Santa Ana. Some of their adobe homes were still occupied in the 1860s.

While the Rancho Santiago de Santa Ana was devoted primarily to cattle ranching, some of the land was set aside for farming, and the family built the area's first irrigation ditches to bring water down to their fields from the Santa Ana River.

In 1821, Mexico broke away from the Spanish Empire, taking California with it. New laws soon followed, allowing citizens of good standing to receive actual land grants of up to forty-eight thousand acres. In 1834, the missions were secularized, with the churches left to the padres and their lands taken by the government, opening up thousands of acres for new *rancheros*.

Bernardo Yorba (1801–1858) was the most prominent of the second generation of the Yorba family and one of the most successful rancheros in Southern California. *Courtesy the First American Corp.*

José Antonio Yorba's sons began to expand the family's cattle empire. Bernardo Yorba received a grant for the lands north of the Santa Ana River, in what is now Yorba Linda. Later, he acquired two adjoining ranchos in Riverside County. Teodosio Yorba requested the hilly land on the east side of the Rancho Santiago de Santa Ana. His 47,220-acre Rancho Lomas de Santiago (the Hills of Saint James) later became part of the vast Irvine Ranch.

At the peak of the rancho era, the Yorba and Peralta families controlled more than 200,000 acres and could ride from what is now the edge of Riverside all the way down to Newport Bay without ever leaving their family's property.

Fiesta!

The Parker family was one of the first Anglo families to settle in Orange, arriving here in 1872. In later years, the youngest son, Joshua E. Parker (1853–1940), loved to tell stories of the early days, including those last bits of the old *Californio* life that survived into the 1870s:

> *Upon arriving here in 1872, my father and the T.J. Lockhart family, cousins of ours, purchased the old Rodriguez hacienda of 1,200 acres on the Camino Real. The Lockharts bought 4,000 sheep from the band on the Rancho San Joaquin and continued in the sheep-raising business. We went into the nursery business.*
>
> *In 1872, the time of which I speak, all of this land around what is now Orange was without trees, for there was no irrigation system to make the growing of trees possible. This vast plain was used for the grazing of sheep, horses, and cattle.*

The Rodriguez adobe was the last of a cluster of adobe homes west of downtown Orange along El Camino Real. It was built in the 1860s by Francisco Rodriguez, who bought a portion of the Rancho Santiago de Santa Ana from one of José Antonio Yorba's sons in 1860. In 1872, he sold out to the Lockhart family. The adobe stood near the northwest corner of Chapman and Feldner. It was torn down in 1919. *Courtesy the First American Corp.*

A Brief History of Orange, California

Life in those days was far from dull, for we could always look forward to a fiesta at one of the haciendas scattered throughout the valley. These feasts took place every two or three months and sometimes oftener. In fact, every time that any member of a California family thought he had a faster horse than those of his relatives scattered throughout the state, he issued a challenge and this was taken as a signal for all to gather together for feasting, dancing, exchange of news, cock fighting, music, laughter, story telling, and racing of the horses. Work was work in those days, surely, but I must say that play was most certainly play. *Those happy times will never live again except in the memory of the few still living who took part in those gay events.*

In the fall of the year, September 16th, Mexican Independence Day, when the most important races took place, whole families, together with their servants, would come from their homes as far north as Santa Barbara and Santa Maria and even farther north than that sometimes. I remember the two Lopez boys, Benito and Juan Chulico *(nicknamed so because he was considered tricky), were nearly always present from the Lopez ranch in Baja California. The younger men and girls rode horseback while the elderly women and very old men with the servants and many provisions jolted along in the creaking* carretas.

Twenty or thirty horses were brought along from each ranch to take part in the races, and the whole herd would be turned out to graze along the river in charge of a few guards who saw to it that they stayed within bounds. This was never a difficult task for the grass was very plentiful and the animals were glad of the opportunity to eat their fill after the long journey from the home ranches.

At all of the ranches there were walled-in enclosures, some of them a hundred feet square, the same being necessary to keep livestock away from the houses and give protection to the gardens. Ramadas were built within these courtyards and the ground beneath was sprinkled with ashes and wet down with water to give a hard, smooth surface for the dances that took place on every evening after the races. Sometimes it took two or three weeks of racing before the final winner was determined by the process of elimination.

There was a good racetrack on the Yorba rancho up the river, another on the Serrano place between El Toro and the grade leading to the old Modjeska place in Santiago Canyon, and one on the Rodriguez place where we lived. All of these courses were straight-aways, one-half mile in length.

All of the horses of this period were mustangs—not very large but with considerable speed and endurance. Horses of a better breed were later

brought down from the agricultural district around Petaluma, north of San Francisco. As work animals the mustangs were useless, but for racing and other uses to which the Californians put them, they were very good indeed.

As there was very little money in this district in those early days, it might be thought that the betting was rather tame. Not so; for there were the cattle, the horses, the land, and many other things of no mean value that could be wagered; such as silver mounted saddles, spurs, fine sombreros *and so on, down to the very shirt a man was wearing. Many is the time I have seen a man, his eyes glittering with excitement, skin off his shirt to wager it on the outcome of a race, while the crowd shouted, cheered, and screamed encouragement. I never hear the modern expression, "I'll bet my shirt," that I don't think of those days, when it really was done.*

Following the races for the day, everyone rode to the ranch where the dance of the evening was to be. Of course they were tired and hungry, and food was always ready for them. Each family had a large iron cauldron encased in adobe bricks with a chimney rising at the rear to carry off the smoke from the fire that was built underneath. This cooking arrangement was in the courtyard, and sixty or seventy gallons of food could be prepared at one time. Sometimes plates were used, but often the food was enfolded in a tortilla and eaten in that way. Everyone, including the family of the house, ate outside. No tables were provided. Each person ate wherever he or she happened to be, either standing or sitting. They would all excitedly discuss the day's events. The food was simple, but it satisfied the pangs of hunger and gave strength for the baile, *or dance, that was to follow.*

Soon the guitars would be playing lively music for the old Spanish dances. Ramon Yorba played the violin and played it very well, too. The women would appear, richly dressed in silks and velvets, wearing their bright rebozas *and gay "Spanish" shawls imported from China.*

Following the dance, groups would leave by horseback to put up at the different ranches throughout the valley, the creak of their saddles, clink of their spurs, and sound of their voices in laughter and snatches of song floating back in the balmy air of the night, growing fainter and fainter until at last all was still and another day of merrymaking was finished. A few short hours of rest followed and then the next day brought forth a renewal of activity, usually as exciting as the day before.

A Brief History of Orange, California

The End of an Era

In 1848, at the close of the Mexican War, ownership of California passed from Mexico to the United States. The gold rush that began that same year brought wealth to the old Mexican rancheros of Southern California, providing a ready market for beef to feed the hungry miners. Cattle that were once worth perhaps four dollars for their hide and tallow could now be driven north to be sold for beef for as much as seventy-five dollars a head.

But the good times could not last. With American statehood came new laws and property taxes that weighed heavily on the rancheros, and as the gold rush slowed, the demand for beef faded. The rancheros began to borrow money or sell shares of their ranchos to stay solvent.

Abel Stearns, an American pioneer who had come to California in 1829, took advantage of the situation. Through purchase and foreclosure, he assembled one of the largest cattle-grazing empires in Southern California, including a share of the Rancho Santiago de Santa Ana.

Then, in 1863–64, a terrible drought swept across Southern California; streams dried up, plants withered and cattle died by the thousands. Now it was Abel Stearns who found himself in debt, struggling to avoid bankruptcy. In 1866, he filed a lawsuit to break up the Rancho Santiago de Santa Ana. Up to that time, the old rancho had been considered one huge, seventy-nine-thousand-acre parcel. The Yorba and Peralta descendants, and new owners like Abel Stearns, simply owned an undivided interest in the entire rancho. Stearns's lawsuit sought the partition of the rancho, so each individual owner would have a defined piece of property that could be bought or sold, mortgaged or foreclosed. Freeing up the land would free up some of Stearns's finances.

The lawsuit spent more than two years working its way through the courts. Complex family relationships across three generations of Yorbas and Peraltas had to be sorted out, and scores of deeds had to be studied to determine just how much interest each owner was entitled. In 1868, three court-appointed referees divided the land among more than one hundred claimants. Even the smallest parcels were at least 25 acres; James Irvine and his partners were given more than 12,000 acres. Abel Stearns received 1,385 acres.

The breakup of the old Rancho Santiago de Santa Ana set the stage for big changes in the southern end of Los Angeles County.

Chapter 2
A TOWN IS BORN

I stopped off the stage at Santa Ana; I had seen Mr. Tustin at the hotel in Los Angeles and he had invited me to settle at his place called Tustin City. But he had no water ditch as yet and I had brought with me 500 rooted grape vines and must have water to get them out. I was told that three miles from Tustin there was a small water ditch and a town laid out called Richland. So I started for that place, getting directions from Mr. Spurgeon at Santa Ana. I found a trail that led in the right direction and following it up I came to a little house where two men were at work digging a well. This was Mr. Putnam's place. I made inquiry for Richland and they said I was already in the place, but for the life of me I could not see it.
– Nathan Harwood, a pioneer of 1872, Orange Post, *January 14, 1899*

Orange was born out of drought and debt—and opportunity. The legal wrangling over the partition of the Rancho Santiago de Santa Ana required the services of some of Southern California's best attorneys, among them Alfred Beck Chapman and Andrew Glassell of Los Angeles. They represented a number of the Yorba and Peralta heirs, in some instances taking their fees in land instead of cash. Chapman and Glassell were also defendants in the lawsuit. Like Stearns, they had been buying up shares of the old rancho for several years, and in the final partition, Alfred Chapman received more than 4,840 acres and Andrew Glassell was assigned 4,000 more.

Andrew Glassell's parcel was on the southern end of the rancho, in what is now Costa Mesa. After it was sold to new owners, it became known as the Banning tract. Alfred Chapman's share was north of the Santiago Creek, where Orange is today. He soon bought several adjoining parcels (including Abel Stearns's share). Some of the land was purchased for as little as eight

RICHLAND DISTRICT,
LOS ANGELES COUNTY.

SUPERIOR LANDS FOR SEMI-TROPICAL FRUITS,
Beautifully located, under the flow of the A. B. Chapman Canal.
Located Five miles Southeast of Anaheim.

———o———

These lands are subdivided into lots of from 10 to 40 acres, well watered, sheltered, and above the influence of frosts. A large number of thrifty settlements on different portions of this large tract exhibit to the eye the best proofs of the very superior qualities of this section of our county.

The terms of sale are reasonable, and made to accommodate the industrious

Capt. W. T. Glassell, the Agent of the owners, lives on the place.
Address
W. T. GLASSELL,
Anaheim,
LOS ANGELES CO., Cal.

An 1873 ad for Richland (soon to be renamed Orange) promises success for "industrious" settlers. *From* Homes in Los Angeles County *(1873)*.

cents an acre. It extended Chapman's holdings east into the foothills and all the way north to the Santa Ana River.

The river was key to Chapman's plans. In 1870, the Chapman tract was surveyed into smaller farm lots, and he began construction of an irrigation ditch down from the river (Canal Street in the northern end of town still follows part of its meandering route.) Chapman called his new development the Richland Farm Lots, and the property first went on the market in December 1870.

But Alfred Chapman and Andrew Glassell had a busy law practice in Los Angeles. So they hired Glassell's brother, Captain William T. Glassell, to manage the new tract. Captain Glassell was a career navy man who had fought for the Confederacy during the Civil War. Twice imprisoned in Union prisoner of war camps, he had come west for his health after the war.

"I may have been a fool," Glassell wrote some years later. "I supposed or believed that the people of the South would never be conquered. I hardly hoped to live through the war. Though I had no intention of throwing my life away, I was willing to sacrifice it, if necessary, for the interests of a cause I believed to be just."

A Town Is Born

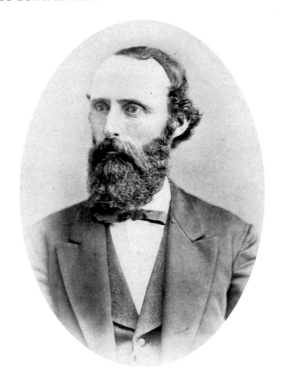

Captain William T. Glassell (1831–1879) guided the fortunes of Orange during its formative years. As his health failed in the mid-1870s, he was forced to give up his work as a tract agent. "It has only been during the absence of the Captain that the good effect of his presence and enterprise in promoting the growth of Orange has been felt," a local reporter noted in 1874. *Courtesy the Orange Public Library and History Center.*

As the irrigation ditch neared completion in the early summer of 1871, Captain Glassell laid out an eight-block townsite around an open Plaza Square. Originally known as Richland, the townsite stretched from Almond to Maple Avenue and from Grand to Lemon Street—still the heart of downtown Orange today. Around it were ten-acre farm lots, which were soon sold to men whose names survive to this day as local street names, such as P.J. Shaffer, Nathan Harwood and Albert B. Clark. Captain Glassell proved a good salesman, and town and farm lots sold quickly. By the end of 1871, there were about a dozen houses in and around Richland.

Why did Chapman decide to put Orange where it is? Water was obviously a key factor, and he needed a spot with good soil for farming. The Los Angeles to San Diego stage road also passed nearby, following the old Camino Real. "The land was luxurious with grass and wild flowers," historian Don Meadows wrote. "Scattered patches of wild buckwheat and artemisia with clumps of cactus spread everywhere and…[to the] south a wall of yellow mustard, six feet tall, formed a barrier of wooden growth."

Richland was not the only new town born of the breakup of the Rancho Santiago de Santa Ana. In 1870, William H. Spurgeon laid out the town

of Santa Ana. Not long after, Columbus Tustin founded the town that still bears his name. Spurgeon had the best location, near the center of the valley and not far from the stage road that followed the old El Camino Real, but Richland had the better water supply. "Uncle Billy" Spurgeon also lived in his town and poured his profits back into its development, whereas Chapman and Glassell were absentee landlords, carrying away their profits. Before long, it was clear that Santa Ana was going to be the leading community of the area. Tustin ran a poor third to both towns.

Richland grew slowly for the first few years. A school was established in 1872. Alfred Chapman donated the property (where Chapman University's law school is now located), and the community built the schoolhouse. The first general store, run by the Fischer brothers, opened a year later at what is now 100 North Glassell. The Methodists also founded Orange's first church in 1873. Now in their third sanctuary, they are still worshipping on the same property given to them by Alfred Chapman.

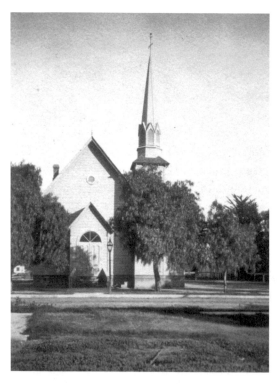

The First Presbyterian Church was the second church in Orange. They built their first sanctuary at the southeast corner of Maple and Orange in 1881. It was used for Sunday school classes after a new church was built in 1912. The congregation now worships in their third sanctuary on the site. *Courtesy the Don Meadows Collection, Special Collections, the UC–Irvine Libraries.*

By the summer of 1873, the community had grown large enough to demand its own post office, so an application was sent to Washington, D.C. But it turned out there was a problem—there was already a Richland, California, up near Sacramento. If the town wanted a post office, it would have to come up with a new name.

There is an old, old story that Chapman, Glassell and two other men each favored a different name and played a game of poker to decide who would get to rename the town.

A Town Is Born

The problem is that it's just that—an old wives' tale that doesn't even appear in print until almost sixty years later.

Others will tell you that Orange was named for all the orange groves that surrounded the little town. But in 1873, there was hardly an orange tree to be seen here, and except for a couple old trees up around the Yorba family adobes at Olive, none of them was mature enough to be producing any fruit.

Even in 1873, there was talk of slicing off the southern end of Los Angeles County and creating a new county to be called Orange County. And even though oranges were not yet a major crop, the name had a lush, semitropical feel to it that local boosters hoped would lure settlers to the area.

So in 1873, Richland became Orange, and in time, the community would more than live up to its name.

Pioneer Plantings

In the early 1870s, grapes and grain were the big cash crops in this area. Wheat, oats, barley and corn were widely planted by the first settlers. With no easy way to ship fresh fruit, the grapes were generally dried in the sun to make raisins. The first local vineyards were planted in 1872, and by 1876, there were more than 200,000 grapevines growing in and around Orange.

The most successful raisin growers in Orange were the McPherson brothers (Robert and Stephen), who bought eighty acres along the Santiago Creek in 1872. Within a few years, they had built their own packinghouse and were shipping raisins by the ton. There were also some wine grapes grown in the Orange area, although Anaheim was always the wine-making capital of the region. Joseph Young was the best-known local vintner, establishing his winery in 1876 along the south side of Fairhaven Avenue, just west of Cambridge Street.

In an effort to find what crops would do the best here, other pioneers tried just about everything you could imagine (and several things you wouldn't). The most unlikely plantings were the semitropicals—bananas, guavas and even pineapples. Few of them lived beyond the first good Santa Ana wind.

Among the other tree crops tried here in the early days were lemons, limes, walnuts, almonds, peaches, apples, figs, olives (for oil), pomegranates and prunes. Vegetables and other row crops were also planted, including beans, peas, potatoes, strawberries, tomatoes, peanuts, watermelons, beets, sweet potatoes and melons. Others tried tobacco and even hops. Vegetables did well on the west side of town, in the lowlands closer to the Santa Ana

River, and the West Orange area was jokingly known as "Pumpkinville" during the early days.

After much trial and error, oranges, apricots and walnuts emerged as the leading tree crops (where there was enough water available). Closer to the foothills, vegetables and berries did well. Grain and grapes also continued to be harvested, but in 1886, a mysterious disease began to sweep through the vineyards, killing vines by the thousands. During the 1886–87 season, the grape blight wiped out about 160,000 vines in the Orange area. The toll was even heavier in the vineyards of Anaheim. In fact, the grape blight was commonly known as the Anaheim Vine Disease (much to the disgust of that community). It was only years later that it was learned that the blight was a virus carried by insects from plant to plant.

The grape industry never fully recovered from the blight. The McPherson brothers went bankrupt. Joe Young replanted his vineyard and stayed in the wine business until about 1910. After that, grapes were no longer grown as a commercial crop in Orange.

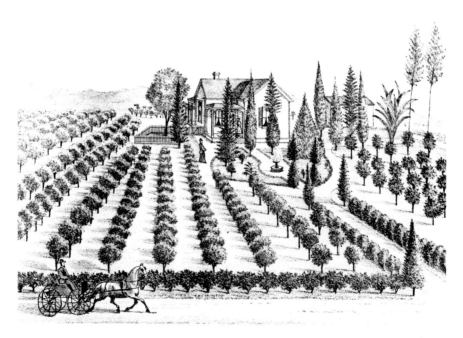

Martin Adams's home and orange grove, a typical pioneer ranch, 1880. Adams came to Orange in 1879 and settled about a mile west of downtown. He lived here until his death in 1908. *From* History of Los Angeles County *(1880)*.

A Town Is Born

Water Wars

Where to find water was a constant challenge in the early days of Orange. It was quite literally a matter of life and death for the young community and its crops.

When the town was founded, Alfred Chapman and his partners controlled almost all the irrigation water flowing into Orange. In 1873, he organized the Semi-Tropic Water Company, but he and Andrew Glassell were still the major stockholders and controlled the company's affairs. The Semi-Tropic Water Company enlarged the old Chapman ditch and extended it to Santa Ana and Tustin. There was some grumbling about the cost of water and the reliability of the Semi-Tropic's irrigation ditches, but on the whole, farmers were getting by.

Then, in 1877, a drought hit the area, and the Semi-Tropic Water Company began diverting more and more water out of the Santa Ana River. That put the company in direct conflict with the Anaheim Water Company, which had been taking water from the north side of the river since 1859. By that summer, there simply wasn't enough water to go around, and the Semi-Tropic's men threw a brush dam across the river above the Anaheim ditch and "wrongfully, unlawfully and with force of arms" channeled as much water as they could into the Semi-Tropic ditch. Both companies sent armed men to the river to protect their ditches. There were a few scuffles, but the real battle would be fought in court a few years later.

The drought brought all the complaints against the Semi-Tropic Water Company to a head. In a rare meeting in Orange, the Semi-Tropic board of directors suggested that if the local ranchers were dissatisfied with the company, why not form their own company and buy out the Semi-Tropic? So that's just what they did.

On August 6, 1877, the Santa Ana Valley Irrigation Company (SAVI) was incorporated to serve twenty thousand acres of farmland in and around Orange, Santa Ana and Tustin. Shares in the company were tied to the land—one share per acre—so the local landowners would always be in charge.

The SAVI immediately set out to improve the original water system. The main ditch was enlarged, the intake was moved farther up the Santa Ana Canyon and two tunnels, totaling nearly a quarter mile in length, were dug through the hill at Olive to bring in the ditch at a better elevation. The fifty-foot drop at the mouth of the tunnels also provided power for a flour mill, which opened in 1882. Originally located in what is now Eisenhower Park,

the Olive Mill remained in operation until 1932 and was an important local industry for decades.

Along with the old ditches, the SAVI also inherited the legal battles between the Semi-Tropic Water Company and the Anaheim Water Company. In 1880, Anaheim sued the SAVI for a fair distribution of water, and the lawsuit dragged through the courts for years. Anaheim claimed a prior right to all the water it wanted, based on an 1857 deed from Bernardo Yorba that allowed the company to build its irrigation ditch. The SAVI maintained that as a successor of the old Rancho Santiago de Santa Ana, it had a right to half the water in the river because its lands reached right up to its banks ("riparian rights" is the fancy legal term). Anaheim won the first round, but the California Supreme Court overturned the ruling in 1883, deciding that Anaheim had only acquired the right to dig a ditch across Yorba's land, not a guarantee of any water to fill it.

Faced with the inevitable, Anaheim agreed to a 50/50 split of the waters of the Santa Ana River. In later years, the two companies would work together on several projects to improve the flow for both sides of the river and to fight against upstream irrigators in Riverside County to make sure this area continued to receive its fair share of river water.

The SAVI kept on expanding and improving its delivery system through the years. At its peak in the 1930s and '40s, the SAVI had about eighteen thousand acres "under the ditch." The company continued to supply irrigation water until the end of 1974. In 1977, the remaining stockholders sold out for nearly $9 million to two Sacramento investment firms that began developing the SAVI's extensive landholdings in the Santa Ana Canyon.

Transportation was also key to Orange's early agricultural development. In the early 1870s, Orange was only connected to Los Angeles by stage road, and a primitive port had been established on Newport Bay—a long haul either way for local farmers. In 1875, the Southern Pacific (SP) built the first railroad into the area, south from Los Angeles as far as Anaheim. It was extended to Santa Ana in 1877.

In those days, the railroads demanded what were politely called subsidies of cash and real estate before they would lay tracks into a new town. Santa Ana offered the SP a substantial incentive, but Orange couldn't raise enough money. The town offered the SP a depot site but no cash. So the railroad ignored Orange and built its new line three miles west of town. It was not until 1880 that the SP even bothered to build a depot at what it called West Orange. It was located near the corner of Flower Street and La Veta Avenue—a spot now buried under the concrete of the "Orange Crush"

A Town Is Born

freeway interchange. The station remained in operation until 1918. In the early days, stagecoaches brought passengers, mail and freight from the trains into downtown Orange. The railroad allowed for fresh fruit to be shipped long distances and opened up new markets for local growers.

Around the Plaza

By the late 1870s, Orange had grown into a pleasant little farming community. A promotional pamphlet from 1879 boasts:

> *The population of Orange numbers about fifteen hundred. At the center is a commodious hotel, two stores of dry goods, groceries, etc.; one for the sale of agricultural implements, one drug store, one shoe shop, one large blacksmith establishment, a post office, express office, etc.*
>
> *The district is rapidly filling up with men of intelligence and culture. Already three churches are organized and the M[ethodist] E[piscopal] Church has a commodious house of worship. A graded school consisting of three departments is maintained and ably conducted by old and experienced teachers.*
>
> *The price of land in Orange ranges for unimproved from $25 to $75 per acre, according to location. In general, however, $25 to $40 per acre is asked.*

To count to 1,500 residents, the author would have had to include everything that is Orange today and more besides, not just the little town clustered around the Plaza Square. The 1880 census counted only 679 residents in Orange.

The "commodious hotel" was known as the Orange Hotel. It started life as a sanitarium, built in 1874–75 in an attempt to attract health seekers to the area. Today the address would be 100 South Glassell Street. The two-story concrete building had a balcony on three sides and featured a bathhouse out back. In later years, it served as both city hall and the Orange Public Library. It was torn down in 1905 to make way for the Cuddeback Building, which now occupies the site.

The two stores were J.W. Anderson & Co. and Crowder's Store, which faced each other on either side of North Glassell along the north side of the Plaza Square. Robert Crowder sold out in 1882 to D.C. Pixley, who went on to become Orange's leading merchant at the turn of the century.

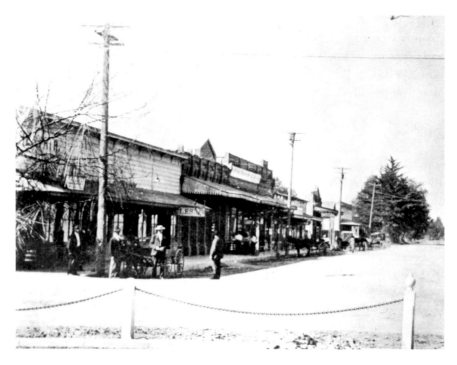

Looking north from the Plaza along the west side of Glassell, circa 1906. On the far left, the first store building in Orange still stands. Farther down are two of the first brick buildings in town, the Schirm Bakery, with its peaked pediment, and the Pixley Store. Both buildings still stand under new façades. *Courtesy the First American Corp.*

The drugstore had been started in 1875 by "Doc" C.B. Andrus. It passed through several hands before being bought out by Kellar Watson in 1899. Watson's Drug Store still serves downtown Orange today, though now only as a restaurant and gift shop, the drugstore side having closed in 2011.

A Taste of the Orient

Like many pioneer communities in California, Orange also had its own little Chinatown in the early days. The Chinese population here was never very large, but it was well known. There was a certain fascination about these men from another part of the world. Some viewed them with suspicion, but others found them dependable employees and trustworthy businessmen.

The first Chinese laundry here opened in 1875. Other men came to work as farmhands, did construction work (including helping to dig the SAVI

irrigation tunnels at Olive), worked as household servants or sold vegetables. As late as the 1920s, Chinese vegetable peddlers could still be seen on the streets of Orange.

Orange's first Chinatown was located on the 100 block of North Orange, near the Presbyterian Church (which brought in Chinese-speaking preachers from time to time to share the Gospel). In the early 1890s, Chinatown moved to the west side of South Glassell, just north of Santiago Creek on the Gardner Ranch. A few other Chinese lived and worked on the outlying ranches.

Our Chinatown was small—just three or four buildings, including a bunkhouse where most of the men lived. The population in 1900 was only sixteen, versus fifty-four in Anaheim and twenty-five in Santa Ana. There never seem to have been any Chinese families in early Orange, though some of the men had families back home in China. The Chinese paid regular rent and were considered good tenants by the Gardner family.

Wing Wor had a store in Chinatown that sold eggs, produce and Chinese goods. There were several laundrymen over the years. Goon Gay (almost always spelled that way in early accounts but pronounced "Hung Kee") had a laundry here for more than fifteen years.

Yick Sing was the leading figure in Orange's Chinatown until his death in 1919. He had previously run a store in Santa Ana's Chinatown. He lived in his own little shack and served as something of a labor contractor, providing farmhands as needed for local ranchers.

Sing Lee had the last laundry in Chinatown, from 1912 until 1924, when county officials ordered the buildings torn down. The Gardners offered to rent a house in another part of town for the few remaining Chinese, but they turned them down, and Orange's Chinatown faded into history.

Bandits in Downtown

Orange was hardly a Wild West town, but crime was definitely part of our early history. Horse thieves were common in the 1870s, and there was at least one shootout on the streets of downtown between a saloonkeeper and a disgruntled customer.

But the most famous robbery in the early days was in 1880, when a group of bandits robbed one of the downtown stores. Nearly forty years later, Alice Armor, the former editor of the *Orange Post*, recalled the raid:

A Brief History of Orange, California

Early in the history of Orange, R.L. Crowder built a store on the northeast corner of the Plaza, where the Edwards Block now stands [101 North Glassell]. *He and his wife occupied rooms at the back of the store and their daughter Mamie was born there. Quite a thrilling incident occurred in this store a few years after it was built. On a rainy winter evening a group of men had gathered to spend an hour to two in setting to right the affairs of the state and the nation, as men are wont to do. Between 8 and 9 o'clock four horsemen rode up and three of them dismounting entered the store, leaving the fourth in charge of the horses. The men were armed and masked and proceeded to make themselves very much at home. They compelled Mr. Crowder and his guests to lie down upon the floor, having first tied their hands and put gunny sacks over their heads. One or two men passing on the street were brought in and made to join the recumbent company. Among the victims were the late Sam Rusk and Henri F. Gardner, the latter being still an intermittent resident of this city. George J. Mosbaugh, now of Santa Ana, Mr. Crowder's bookkeeper, was at his desk at the back of the store.*

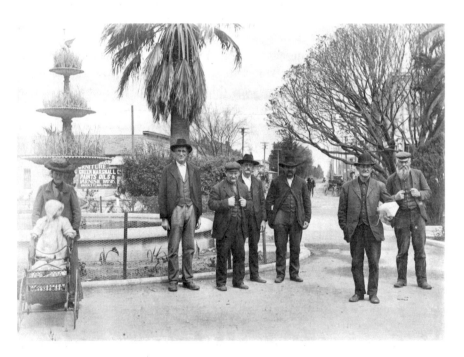

For years, the Plaza was a gathering spot for the old-timers in Orange, who would sit and watch the world go by, discussing the affairs of the day. The locals dubbed them "the Plaza Statesmen." In this photo from about 1906, a woman and her child have stopped by on their way through downtown. *Courtesy the Orange Public Library and History Center.*

A Town Is Born

Hearing an unusual noise, he stepped from behind his desk to see what it meant, when he, too, was seized and added to the collection on the floor. Mrs. Crowder was in the living room at the back of the store and had just put her baby to sleep, when, hearing the racket, she peeped through the door. The robbers dragged her into the room, seated her in a chair, and one of them held a pistol to her head, compelling her to tell where the various things they wanted could be found. Mrs. Crowder was game and made no outcry, being chiefly concerned lest her baby should waken and cry. The bandits took knives, blankets, clothing and such provisions as they could carry away on their horses. The safe being open, they looted that, and also went through the pockets of the men on the floor. One of the robbers remarked that, "the floor panned out better than the safe." Some $80 was taken from Mr. Rusk, and smaller sums from the other men. Finally, having secured such booty as they could conveniently carry, they mounted their horses and rode away, having first threatened the men with dire calamities if they moved for fifteen minutes. Mrs. Crowder, disregarding these threats, immediately released the men from their cramped position, but as there were no telephones in those days the robbers made good their escape before any pursuit could be organized. They proved to be members of a somewhat notorious company of bandits, all of whom were afterward captured at various times and places, the last, as I remember, being shot at Downey in a raid similar to that at Orange.

Chapter 3
BOOM AND BUST

The boom? Though only seven or eight years of age, I well remember an auction of lots between McPherson and El Modena, with a sweating, shouting auctioneer reeling off words at what seemed to me an impossible rate. And another, of the 20-acre Yarnell tract at the southwest corner of Chapman and Batavia.
For that auction, a trainload of people was brought down from Los Angeles on the Santa Fe, just completed. Food was supplied. I don't remember anything about the food, excepting that I do remember they had watermelons. It seems to me now that there never was such a pile of watermelons as I saw stacked up there.
I was more interested in watermelons that I was in town lots, but my uncle, M.V. Adams, wanted a lot that adjoined our old home place over on Main Street. He got it, and paid $600 for it.
—*Terry Stephenson, Orange County historian,* Orange Daily News, *April 30, 1938*

In 1885, Orange was barely a teenager. Perhaps one thousand people lived in what is now the city of Orange. Grapes and grain were still the principal crops, but oranges were beginning to come into their own. The first brick store building was built downtown in 1885, the Orange Public Library Association was formed and Orange's first newspaper, the *Orange Tribune*, began publication.

Orange had developed its own identity as a quiet, temperance-minded, church-going town. Almost all the needs of everyday life were available downtown, even if some larger purchases required a trip to Santa Ana or perhaps Los Angeles. All in all, the future seemed bright.

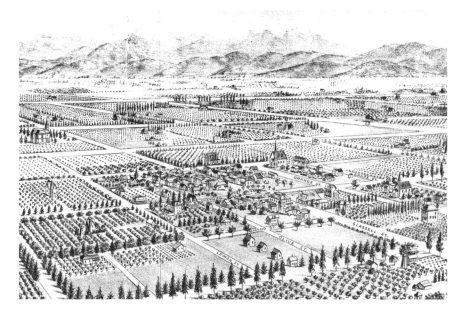

A bird's-eye view of Orange in 1886, looking northeast across downtown. The sketch is surprisingly accurate, considering the fact that the artist had no way to fly over town. *From Orange, Cal., Illustrated and Described (1886).*

THE BOOM OF THE EIGHTIES

But there was change on the horizon. For years, the Southern Pacific Railroad had enjoyed a monopoly on rail traffic in Los Angeles County as only a railroad could, charging whatever it pleased and serving only the towns that made it worth its while. But in 1885, the Santa Fe Railroad came over Cajon Pass into Southern California and ended the reign of the SP. The two railroads soon got into a rate war, dropping prices to lure both settlers and tourists to the area. Both railroads knew that as Southern California's population grew, it would only mean more business for them.

Ticket prices began dropping in 1886 as the two railroads struggled for dominance, but the real rate war was in March 1887 and finally bottomed out with fares from the Midwest advertised at just $1 a ticket. It was just an advertising stunt, of course, but fares remained as low as $25 a ticket for the next year or so—a long way from the $125 they had cost before the rate war began.

The rate war between the Santa Fe and the Southern Pacific touched off a frantic real estate boom in Southern California. In less than three

Boom and Bust

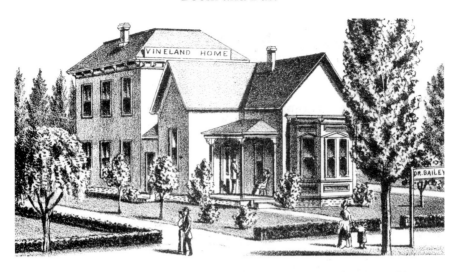

The Vineland Home was built in 1886 by Dr. W.F. Bailey at the rear of his home. He hoped to lure health seekers to Orange and provide them with rooms, meals and medical care. Dr. Bailey's home is long gone, but his hotel still stands on West Chapman Avenue and is currently being renovated to house a restaurant. *From* Orange, Cal., Illustrated and Described *(1886)*.

years, dozens of new towns and hundreds of new subdivisions were laid out, business expanded and the population surged. The "boom of the eighties" set the stage for much of Southern California as we know it today.

In 1886, the Santa Fe began construction on a new rail line down the Santa Ana Canyon, and Orange was determined not to be left out in the cold this time around. A public subscription was held, and local residents offered the railroad $50,000 in cash and property, including a depot site and a right of way just west of downtown. The Santa Fe took the bait, and the new line turned south at Olive and reached downtown Orange in August 1887. A depot was built a year later, with a little park added in 1891.

As the railroad approached, Orange began to grow. New subdivisions ("additions," as they were called at the time) were laid out around the original townsite, converting farmland into building lots. Most were launched with an auction sale, with the lots offered for just 10 percent down and easy terms. Newspaper advertisements and promotional brochures sang the praises of each new tract, and real estate agents met the trains to tout their latest offerings.

The railroads also helped promote Southern California, hoping to lure more tourist traffic to the area. The tourists came mostly for the winters, drawn by Southern California's mild climate. Any town worth its salt soon

Grand Sale!

42 Choice Residence Lots. 42

— IN THE —

Culver Home Tract,

— AT —

∹ ORANGE ∹

On WEDNESDAY, March 30th,

BEGINNING AT 10 O'Clock, A. M., under the Management of

A. L. TEELE, - - **Los Angeles.**

☞ NO LOTS SOLD or PROMISED until the Books are Opened at 10 A. M., on the Day of Sale. ☞ FIRT COME, FIRST SERVED.

THESE CHOICE LOTS front on GRAPE, SHAFFER, ALMOND and BEACH Streets, 50x132 Feet in size, and are only Two Blocks from the NEW VILLA HOTEL, THE PALMYRA, insuring to purchasers the Most Desirable surroundings, and all Conveniences. IRRIGATION WATER RIGHTS with Each Lot.

Terms of Sale.

ONE THIRD CASH, One Third in One Year and One Third in Two Years. Deferred Payments secured by Notes and Mortgages, with interest at Ten per Cent per annum until paid. An ABSTRACT OF TITLE to Property furnished each Purchaser, free of charge. For further information, apply to

C. Z. CULVER,
TRAVIS & SMITH,
SEEBER & SCOTT, } Orange. **A. L. TEELE,**
LOCKHART & CLAYTON,

34 North Spring St., Los Angeles.

Real estate auctions were common during the boom of the 1880s. The Culver Home Tract ran from Almond to Beach (now Culver) between Shaffer and Grape (now Grand), just two blocks from C.Z. Culver's Palmyra Hotel. From Orange Tribune, *March 26, 1887.*

had a "grand hotel" built by boosters who hoped to turn those tourists into permanent residents.

Charles Z. Culver, Orange's leading booster of the day, rounded up a group of investors to build a twenty-four-room, two-story hotel on South Glassell. Many of the investors came from Palmyra, New York, so the hotel was dubbed the Palmyra in their honor. It opened with a grand banquet in July 1887. The Palmyra featured hot and cold running water in the rooms, a full dining room, a tennis court and a horse-drawn omnibus to meet the trains at the depot.

Boom and Bust

The Palmyra Hotel, at the southeast corner of Glassell and Palmyra, was the queen of Orange's boom-time hotels. Built in 1887, it featured electric lights and hot and cold running water. The building later became an apartment house, and the last of it was torn down in 1970. *Courtesy the Orange Public Library and History Center.*

Plans for a second grand tourist hotel were announced in the summer of 1887. This time, many of the investors came from Rochester, New York. The Hotel Rochester was a three-story brick behemoth built on the southwest corner of Chapman Avenue and Lemon Street. Construction dragged on through the winter of 1887–88, but the building was still unfinished when the bottom dropped out of the boom. It was later used as a private college, an apartment house and even (briefly) as a motion picture studio. It was finally torn down in 1931.

Along with the railroads, Orange also had two streetcar lines during the boom days. The Santa Ana, Orange & Tustin (SAO&T) line began service to Orange in February 1888. The tracks ran north on Main Street to La Veta Avenue, where they turned east toward Glassell Street. Turning left, the tracks continued down the center of Glassell Street all the way to the Plaza. The Orange, McPherson & Modena (OM&M) Street Railway ran up Chapman Avenue from the Plaza all the way to Tom Thumb Hill at the foot of the El Modena Grade. Service on the OM&M line also began early in 1888.

A Brief History of Orange, California

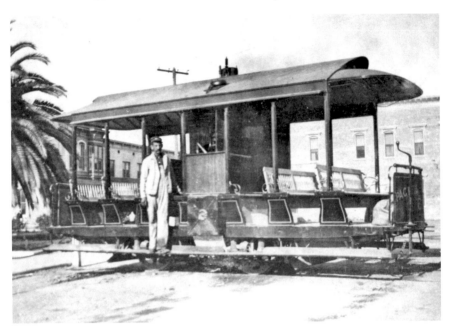

Streetcars connected Orange and Santa Ana beginning in 1888. Originally drawn by horses, after steam engines were installed, locals dubbed the line the Peanut Roaster for its shrill whistle, or simply the Orange Dummy. The line was eventually bought out by the Pacific Electric. *Courtesy the Orange Public Library and History Center.*

Both of these original streetcar lines were "hayburners," pulled by horses or mules. The El Modena line survived until a flood washed out the bridge over the Santiago Creek in 1891. The SAO&T kept rolling until 1895. A year later, the Orange to Santa Ana portion was revived, this time with a steam-powered streetcar that was billed as "smokeless, noiseless, and odorless." That was a bit of an exaggeration. Around Orange it was usually known as the Orange Dummy or the Peanut Roaster because of its shrill steam whistle. It had a top speed of about five miles per hour.

The Dummy poked along until 1901, when it was bought out by the new Pacific Electric (PE) Railway Company. The Pacific Electric went on to create an interurban trolley system that served much of the region in and around Los Angeles. By 1910, it had built three major lines into Orange County—along the coast to Newport Beach; down through Garden Grove to Santa Ana (which connected with the branch line to Orange); and finally through La Habra and Brea to Yorba Linda. By 1914, the PE had moved its tracks from Glassell Street to Lemon Street and replaced the old Dummy with its famous "Big Red Cars." A depot was built near the northwest corner

of Chapman Avenue and Lemon Street in 1918, and passenger service to Orange continued until 1930, when it was replaced by buses from the Pacific Electric–owned Motor Transit Company.

The Plaza

As tourists and settlers flooded Southern California, every town wanted to be seen as an up-and-coming, forward-looking community, ready for new residents. Civic improvements were the order of the day, and Orange did its best to keep up. Cement sidewalks and gas street lamps were installed downtown, brick business blocks began to replace the old wooden store buildings and, in 1886, Orange's first bank—known simply as the Bank of Orange—was organized.

But in the center of town, the Plaza Square remained a weedy, rutted eyesore. Alice Armor, who came to town in 1875, later recalled:

> *Some of the earliest settlers planted pepper trees in the four corners and water was piped from a reservoir on East Chapman Avenue to the center of the square. There was always a miry puddle about the hydrant, where travelers stopped to water their teams. The pepper trees were used as hitching posts and in their shade, wood was piled and packing boxes were stacked. Castoff boots and shoes, old hats, broken crockery and dead hens were scattered here and there. Such was the Orange Plaza in the good old days.*

The Plaza was a no-man's land, muddy in the winter and dusty in the summer. It simply would not do.

So in 1886, a drive began to lay out a park in the center of the Plaza Square and run the streets around it. There was a little debate about just what shape the park should take; some argued for four smaller parks in the corners, with the streets still crossing in the center, but eventually, the circular design won out. (For the record, it is not actually a circle but more of an oval.)

As the men of town went to work with plows and plantings to transform the center of the square, their wives launched their own project. Orange's new park would have a fountain right in the middle of town. To raise the money, the women held bake sales and musical performances and, with the help of their husbands, wrote and produced an original play. *The Plaza, A Local Drama in Five Acts* ran for just two nights in June 1887. It was a spoof of the real estate boom and some of the well-known local characters. It was a huge hit and paid

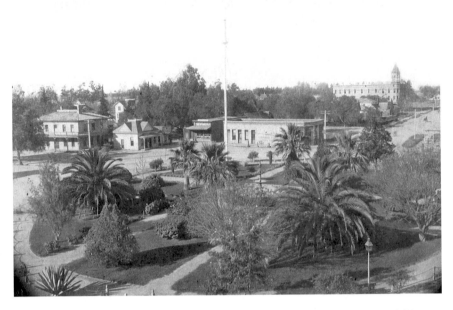

Looking southwest across the Plaza, circa 1898. Two of Orange's early hotels are visible. The two-story Plaza Hotel is on the left. Built in 1874, it later served as city hall; it was torn down in 1905. On the right, in the distance, is the three-story Hotel Rochester, a relic of the real estate boom of the 1880s. Construction began in 1887, but the boom went bust before it could be completed. It was torn down in 1931, and the downtown post office now occupies the corner. *Courtesy the Don Meadows Collection, Special Collections, the UC–Irvine Libraries.*

off the debt on the new fountain, with a little left over for the public library to boot. By the summer of 1887, the new Plaza Park was complete. Some of the original plantings are still in place. The old fountain stood in the center of town until 1937. Later, it saw service as a wading pool in Hart Park. Twice restored, today it stands beside the new Orange Public Library and History Center.

Boom Time Satire

The Plaza presents a rare picture of the boom of the eighties in Southern California—rare because, while there were some excellent satires of the boom published, most were written after the fact and take a bleak view of those hectic months. But *The Plaza* was written at the height of the excitement, when most folks still saw the boom as the bringer of all good things.

Boom and Bust

One of the best scenes is the grand real estate auction. If it isn't what those auctions actually sounded like, it's certainly what we'd like to believe they sounded like. In the play, local rancher Ignorance Bliss has finally caught the bug and agreed to subdivide part of his orchard for town lots. Real estate huckster George Washington Glibb has come down from Los Angeles to conduct the sale; he mounts the platform and addresses the crowd:

> *Ladies and Gentlemen, during all the years of our connection with the public sale of real estate in California it has never before been our pleasure to see gathered before the plan of lots so much beauty, culture and intelligence as beams upon us today. And yet it seems as if you were tired with your night's rest at the Pico, opposite Vineland Home, mingled perhaps with a little tinge of home sickness. You have now but to say the word and all this may at once be dispelled. Tomorrow you may hear the music of the saw and hammer at work on your new houses in the most beautiful portion of the most glorious country that the sun shines on and where there is more pure air and sunshine to the square inch than anywhere on the face of the globe. You must consider yourselves as most fortunate in having the opportunity to secure a foothold in a country toward which the longing eyes of sixty millions of people are turned—one hundred and twenty million eyes on this spot today.*

The Pico House was Orange's shoddiest boom time hotel. In fact, it wasn't even a hotel, just a row of rooms for rent along West Chapman Avenue. The preliminaries out of the way, Glibb then turns to the affairs of the day:

> *It is only by the most urgent request that Mr. Bliss has consented to the sale of these lots. He is willing to make a sacrifice in order to secure as neighbors and citizens the members of this excursion. I see your hands going for your pockets and we will commence this sale at once. You see before you a plan of the Bliss Addition to Richland; lots 50 x 150 feet, terms: cash. The first lot to be sold is on the corner of Angelina and Seraphina streets and has an excellent view of that most wonderful production of art and genius—the town Plaza.*
>
> *There is our young man now, right out there with a blue flag, standing on the lot…Hi'yon, leatherhead, the next one, that's right. Now he's standing on lot No. 1.*
>
> *Now, what do I hear bid for it, make your bids quick, gentlemen.* [Old lady bids $100] *$100 what ma'am, a front foot? These lots are worth $15,000 if they are worth a cent. Make me a bid, gentlemen.* [$1,000 bid] *That will do for a starter. $1,000 make it two.* [$2,000 bid] *Thank you, $2,000 I'm*

> bid, two I'm bid, and I'm bid two, make it three. [$3,000 bid] *Thank you, do I hear four? Three I'm bid and I'm bid, do I hear four? Going at three at three worth $15,000 if it's worth a cent.* [$4,000 bid] *$4,000, thank you. Remember, 50 x 150 feet and I'm only bid $4,000. Don't be bashful, wink your eye or hold up your foot.* [$5,000 bid] *Five, going at five and five I'm bid. Make it six, going at five and six will you make it, going at five and six you will have it, boost her, give I'm bid and I'm bid* [$6,000 bid] *and $6,000, thank you. Why gentlemen this is only half the value, boost her, raise her another.* [$7,000 bid] *Seven I'm bid, seven I'm bid, make it eight and you will have it, make it eight and down she goes. Wink your eye or hold up your foot and down she goes. Seven I'm bid and eight will make it. Boost her, raise her another* [$8,000 bid] *$8,000, thank you, just one half of its actual value.*

Having driven the price up to an outrageous level (dropping a zero from all those bids might take you closer to the prices of the day), Glibb stops to chide his audience with this remarkable bit of verbiage:

> *Ladies and Gentlemen, if you could but realize the great and glorious future of this valley you would not hesitate for a moment at any sacrifice to secure a home in this marvelous country. The wildest imagination utterly fails to convey an idea of its future possibilities.*
>
> *Supposing the whole population of this great Republic were to form themselves into an army of clerks; armed with every quill of every goose in the country, with the Pacific Ocean for the ink bottle. The last man would go down with grey hairs to the grave; the last quill would be worn down to a stump, and the ink bottle exhausted before* one half *of the future possibilities of this country could be told!*
>
> *Think of it! And I'm only bid $8,000 for this lot, worth $15,000 if it's worth a cent.*

And he gets it!

Neighboring Towns

During the boom years, scores of new towns were founded across Southern California. Fullerton, Buena Park, El Toro and Newport Beach are all children of the boom. But others were not so lucky. Towns like Carlton, San Juan-by-the-Sea and Fairview have disappeared with hardly a trace.

Boom and Bust

Closer to Orange, several new towns were born during the boom years. The best known is El Modena, founded in 1886. Most of the early settlers were Quakers from the Midwest. Their church (built in 1887 and rebuilt a year later after it was blown off its foundation by a Santa Ana wind) is now Moreno's Mexican Restaurant on East Chapman Avenue.

Originally, the community was christened Modena, after a town in Italy. But the post office department said the name was too close to Madera and insisted on another name. For a time, the town was known as Earlham, the name of a Quaker college in Indiana. Then someone had the bright idea of adding a Spanish "El" in front of the Italian Modena, and El Modena was born.

(Thirty years later, some purist in Washington decided that El Moden*o* was correct and arbitrarily changed the name of the post office. Most of the locals ignored it and went on calling the town El Modena just like before. It took sixty years to undo that arbitrary change.)

El Modena never had much of a business district; it was primarily an agricultural community, but it did have a fine two-story schoolhouse, a couple of stores, several real estate offices (during the heyday of the boom) and a blacksmith shop. During the boom, a tourist hotel was also built at the foot of Tom Thumb Hill, but it burned to the ground in 1889. El Modena even had its own newspaper in 1888—the *El Modena Record*—but it barely survived six months.

Closer to Orange, the McPherson brothers subdivided part of their raisin grape vineyards in 1886 and founded the town of McPherson on the east side of Chapman Avenue, at McPherson Road. It was primarily a company town, with most of the early residents working for the McPherson brothers, but it did have a store and a post office.

Both towns were connected to Orange by horse-drawn streetcars. Despite a persistent rumor that the horses and mules got to ride downhill to Orange on the backs of the cars, they, in fact, had to pull the cars both ways, uphill and down.

North of Orange, near the Olive Mill, a new town of Olive Heights was laid out in 1887, and a little business district developed along the Santa Fe tracks near what is now Lincoln and Orange-Olive Road.

Olive was once a prosperous little town. The "Greater Olive Expansion Edition" of the *Orange Post* in 1922 lists two grocery stores (the Olive Store and the Olive Mercantile Co.), the Olive Service Station, the Olive Restaurant and Confectionary and, for the gentlemen, the Olive Cigar Store, Billiard Parlor and Barber Shop. Harvey Garber had just moved his brickyard to town; later known as Mission Clay Products, it operated until

1970. The First National Bank of Olive had its own substantial building, where it was in business from 1916 until it closed in 1933, at the depths of the Great Depression. The Olive Garage (which still stands at 606 East Lincoln) survived the longest of the old businesses there. Anselmo Ames ran it from 1935 until he finally retired in 1983. All that, plus the old flour mill and "three large packing houses employing in all more than two hundred people," was part of Olive in 1922.

By 1923, Olive also had a drugstore in a brand-new building in the heart of the business district, run by Lee McClelland for many years before being destroyed in a spectacular fire in 1961. The town had its own elementary school district (with a new campus built in 1919), and St. Paul's Lutheran Church had its own parochial school. Today, the old St. Paul's sanctuary is home to the North Orange Christian Church. Olive also had its own post office until it became a station of Orange in 1963. Much of the community has been annexed to the city of Orange, but a little "county island" of unincorporated Olive still remains at the top of the hill.

The Santa Fe understood the value of its new railroad lines and laid out several new towns of its own along the tracks. In 1887, it founded a town called St. James along the tracks just below Olive. The depot would have been located a little south of what is now Orange-Olive Road and Heim Avenue (originally Anaheim Avenue, later shortened to Heim, the name of an old-time local family). But only a few buildings were ever built at St. James, and with the end of the boom, the town quickly faded away.

Stung by the success of the Santa Fe, the Southern Pacific finally began to extend service to more and more communities. In 1888, it built a branch line across the river from Anaheim and along the base of the foothills north and east of Orange. The line crossed the Santiago Creek at McPherson and continued on south of El Modena to Tustin (part of the old right of way is now a walking trail in North Tustin).

Where the tracks crossed Villa Park Road, the Southern Pacific established a station that it called Wanda—presumably the name of a wife or daughter (or perhaps girlfriend?) of one of the railroad men. The scattered ranchers out there had already formed their own school district in 1881 and named it Mountain View. But once again, when they tried to get their own post office in 1888, they found that name was already taken, so they became Villa Park instead.

Villa Park was never really much of a town, just a country community. Besides the school, there was a Congregational church, a general store and, later, two packinghouses—Villa Park Orchards and Central Lemon.

Boom and Bust

A New Creation

The surge of population and civic pride during the boom years also gave birth to both the city and county of Orange. To the local boosters, it seemed only natural that Orange should incorporate as a city. But they needed a campaign issue to lead the way. They found it in Orange's two saloons. Temperance became the cry of the day. Once Orange was incorporated as a city, they could vote out demon rum!

The campaign started in earnest at the beginning of 1888, with both local newspapers supporting the measure. The only snag was that—faced with such a massive influx of new residents during the boom—Los Angeles County had just thrown out its entire voter registration rolls and required everyone to re-register. So only a small portion of the local population was qualified to head to the polls on April 6, 1888, and cast their ballots. But it was enough—incorporation passed ninety-nine to seventeen.

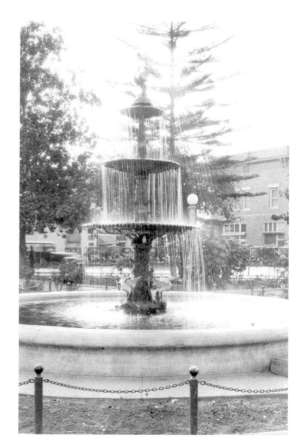

The original Plaza fountain, circa 1925. Installed in 1887, it was replaced by the modern electric fountain fifty years later. *Courtesy the First American Corp.*

The new city of Orange had a population of about 1,500. The city limits stretched north to Collins, west to Batavia and south and east to the Santiago Creek—about three square miles in all.

The first city council was selected at the same election. It was an interesting mix of old-timers and newcomers. William Blasdale (a pioneer of 1875) was selected as the first mayor. He was joined by pioneers P.J. Shaffer and Henri Gardner, who worked for the SAVI. The newcomers were represented by C.Z. Culver and Dr. O.P. Chubb. Culver had promoted the Palmyra Hotel; Dr. Chubb led the investors for the Rochester.

As promised, the city council quickly voted to close the local saloons (although it was not technically their first agenda item, the ordinance specified that it was the first official act of the new city). Unfortunately, the saloon owners simply closed their front doors and starting selling liquor out the back. It was pretty obvious due to the wagons still running back and forth from Anaheim every week, picking up the empties and dropping off full barrels. So in September, a second vote was held to confirm that Orange was going to be a dry city. The two saloons closed for good, and there wasn't another bar in town until after the end of national Prohibition in 1933.

About the same time Orange voted out the saloons, the drive to create a separate Orange County began again. The idea was nothing new; for almost twenty years, the residents of the southern end of Los Angeles County had been pushing for county division. Even the name Orange County had been floating around since 1872. Petition after petition had been sent to the state legislature in Sacramento, and several county division bills were introduced, but all of them failed to pass.

Anaheim had been the early leader in the county division movement; now it was Santa Ana that took up the charge, with town founder William Spurgeon, businessman James McFadden and local assemblyman E.E. Edwards in the lead. As the legislative session opened in 1889, they headed off to Sacramento and went to work. After an intense lobbying effort, the bill was finally approved, calling a special election for June 4, 1889, when local voters could decide for themselves if they wanted their own county. Anaheim and the surrounding communities were unhappy that the northern boundary of the proposed county had been placed at Coyote Creek—they had hoped to be in the center of the new county—and voted largely against the measure, but there were more than enough votes below the Santa Ana River to carry the day.

Now the big question was which town would be the county seat. With Anaheim out of the running, Santa Ana naturally expected to win the prize, but Orange decided to put up a fight, even offering the unfinished

Hotel Rochester as a ready-made courthouse. A second election was held on July 17 to select the first slate of county officers and settle the county seat question. Santa Ana won handily, claiming not only the county seat but the lion's share of the county offices as well. The only upset was Orange merchant Sam Armor, who squeaked on to the board of supervisors over Santa Ana's candidate by just four votes.

Bust

The boom of the eighties was short-lived, a victim of outrageous optimism and more than a little greed. The real estate market became flooded with new tracts and towns. Worse, too many of the lots were sold to speculators (often paying as little as 10 percent down) whose only goal was to hold the land briefly and then sell it at a profit. When the surge of tourism slowed and the banks began tightening down on credit, the whole grand enterprise came tumbling down. Scores of new towns faded away (St. James among them), and thousands of empty lots were sold for taxes.

For all the good it did in prompting local development and civic improvements, too much of the money made on the boom was simply paper profits. A popular joke of the time told of two ex-boomers meeting on the street one day. "I lost $50,000 when the boom went bust," one of them complains. "And worse yet, $500 of that was in cash!"

As the boom died down, C.Z. Culver found himself deeper and deeper in debt. In June 1888, after attending just four city council meetings, Culver resigned, left on a business trip to Baja California and never returned. His debts were later settled at eight and a half cents on the dollar. He was still believed to be living in Mexico as late as 1921.

To make matters worse, at the same time the boom was collapsing, the local vineyards were dying. A mysterious blight swept through the area, killing the vines almost overnight. By 1888, almost all the local vineyards had been destroyed. A few growers replanted, but the grape industry would never be the same.

The collapse of the grape industry, followed by the collapse of the real estate boom, led to some pretty dull times in Orange in the 1890s (a national financial panic in 1893 didn't help matters much either). There were a few bright spots, however—the creation of the Santiago Orange Growers Association and the Orange County Fruit Exchange in 1893, improvements to the SAVI irrigation system and a couple of new church

buildings. West Orange also gained a little more identity in 1890 with the opening near the depot of the original West Orange School, which survived until 1905 (today's West Orange Elementary School opened on its current location in 1924). To the east, James Irvine gave the county 160 acres in an oak grove along the Santiago Canyon for a park in 1897. Originally known simply as Orange County Park, in 1929 it was officially renamed Irvine Park.

A City of Churches

By the time the city of Orange incorporated, there were already six churches in town, and the community promoted itself as a "city of churches" for years to come.

Only two congregations were organized here in the 1870s—the Methodists and the Presbyterians. The Methodists were the first to organize (1873) and the first to build a church (1875). Now known as the First United Methodist Church of Orange, they still worship on the same site, in their third sanctuary. The Presbyterians followed close on their heels, organizing early in 1874. They have been on the same corner downtown since they built their first church in 1881.

One of the differences between the two denominations is that Methodist ministers are appointed by their bishop and in the early days generally served only one or two years before being sent on to another congregation, whereas the Presbyterians "call" their ministers, who often serve for decades. So while the local Methodists had some strong individual preachers over the years, most of them were not in town long enough to make much of an impression on the wider community. The First Presbyterian Church, on the other hand, has been served by a number of longtime pastors who became prominent members of the community. Two pastors served the congregation for a total of fifty-five years between them—Reverend Alexander Parker, who guided the church through most of its early years (1883–1907), and Reverend Robert Burns McAulay, who led the congregation through the dark days of the Depression and on into the boom years of the 1950s (1929–59). Reverend Marcus L. Pearson did not have as long a tenure (1917–26) but left a lasting impact on the community as a leader in the creation of the Friendly Center to serve Orange's growing Mexican American community.

The First Christian Church of Orange was founded in 1883. Their first sanctuary was in the 100 block of East Chapman, on the south side of the

street. In 1887, the church moved to the southeast corner of Chapman Avenue and Grand Street. Later remodeled and added to, the old sanctuary was used until 1961, when the congregation moved to its current location on East Walnut. Several of the pastors of the First Christian Church had close connections with Chapman College when it was still located in Los Angeles and later played a role in helping to bring the college to Orange.

The First Baptist Church began in 1886. After initially meeting in a remodeled schoolhouse, in 1893 the members moved across the street to a brand-new sanctuary at the northwest corner of Orange Street and Almond Avenue. That building (now a restaurant) still stands and is the oldest surviving church building in Orange. In 1958, the congregation purchased the old Maple Avenue School, remodeled the buildings and moved in. They worshipped there until very recently, when they merged with Covenant Christian Church. Orange's oldest Baptist congregation today is the Southern Baptist Church, organized in 1947.

Trinity Episcopal Church was formally organized in 1887 as a mission church and became a full parish twenty years later. In 1910, they dedicated a new church at the northeast corner of Maple Avenue and Grand Street. Trinity moved the farthest of any of the old downtown churches, all the way out to Canal Street in 1971, and built their present sanctuary there in 1979. Their old downtown church served as the Chapman College Chapel for many years.

But in many ways, the most influential church in the early years of Orange was St. John's Lutheran Church, organized in 1882 by Reverend Jacob Kogler. Services at St. John's (and classes at the parochial school, founded a year later) were all conducted in German in the early days and attracted many German-speaking settlers to Orange. But while the congregation preferred to worship in German, there was no language barrier with the rest of the community, and many of the members of St. John's became prominent civic and business leaders.

Curiously, there doesn't seem to have been much connection between Orange's German pioneers and the better-known German settlers in Anaheim, across the river. Religion may have played a role, since Orange's German were largely Lutheran, whereas Anaheim leaned more on the Catholic side. In fact, Anaheim did not have a Lutheran church until about 1920, shortly before Orange's first Catholic parish, Holy Family, was founded (1921).

St. John's soaring Gothic sanctuary on Center Street, with seating for 750, was completed in 1914. The adjoining Walker Hall, featuring an auditorium,

St. John's Lutheran Church's second sanctuary stood on the northeast corner of Olive and Almond from 1893 until its congregation moved into its present church in 1914. *Courtesy the First American Corp.*

gymnasium, kitchen and classrooms, was built in 1927, and the first wing of the present school was dedicated in 1929.

As the years went by, the use of the German language faded at St. John's, first in the parochial school and then in the church. World War I increased the pressure to make the change when questions were raised about the loyalty of the local German population. But as war bond sales soon proved, the community had nothing to fear.

Reverend Kogler retired in 1917 after thirty-five years of leading the congregation. His successor, Reverend N.F. Jensen, brought new ideas to the old church that sadly led to a split five years later, with many of the younger, English-speaking members leaving to found Immanuel Lutheran Church. The split left hard feelings that lingered for decades.

Chapter 4
A GROWING COMMUNITY

The Plaza was a social center. The farmers all came to town on Saturdays and they would hitch their horses. There were hitching racks around the edge of the Plaza, where the trees are now, and the families would go in the Plaza. The little kids would play hide-and-seek in the bushes and what have you, and the old ladies would get together and visit, and the men also. Some of them would bring their lunches when they came from the ranches around. They'd make a day of it. That was their only way of meeting their friends. We all knew one another. All the ranchers around, they all knew one another...

The stores stayed open until nine o'clock at night. We had some pretty good stores here. Every block had two grocery stores in it. In the grocery stores we had groceries, but no fresh perishable fruits and vegetables. There were no fruit stands like we have now. You'd go in and they kept potatoes and onions and eggs and homemade butter...everybody made their own bread.
—*Lena Mae Thompson, born in Orange in 1891, oral history, 1978*

As the new century dawned, Orange was beginning to show some signs of life after the dull days of the 1890s. Following the grape blight in the late 1880s, more and more local ranchers had begun planting oranges. But orange trees need time to grow. It can be six, eight or even ten years before they begin to turn a profit. In the meantime, growers had to get by, raising other crops between the rows of young trees or working for other growers.

And sure enough, about a decade after the collapse of the grape industry, Orange's economy started to recover. By 1905, substantial new business blocks were going up downtown, and there was a steady demand for new

homes in the surrounding neighborhoods. By 1910, Orange's population had reached 2,920; by 1930, it would top 8,000.

King Citrus and Queen Valencia

The citrus industry was the backbone of Orange's economy for more than half a century. During the first half of the twentieth century, much of this area was one vast orchard, with citrus trees—primarily Valencia oranges—stretching for miles in neat, orderly rows, divided by windbreaks of eucalyptus trees and dotted with country homes.

The first local orange groves were set out about 1873. Various varieties were tried here in the early days, including navels, Mediterranean sweets, St. Michaels and Maltas. But it was the Valencia orange (first imported to Southern California by A.B. Chapman) that came to dominate the local crop. The fruit ripened in the spring and could be picked all summer and even into the fall. By 1936, Orange County was supplying one-sixth of the nation's Valencia crop. In 1948, there were 67,263 acres of Valencias in the county—more than five million trees. And that figure doesn't even include other citrus crops, such as navel oranges, limes, grapefruit and lemons.

Most local groves were owned by small growers and were five, ten or twenty acres. Orange trees take six or seven years before they start producing a paying crop and even more before the trees became profitable, so in the meantime, the growers planted other cash crops between the rows of young trees. Tomatoes were especially popular. But once the trees were mature, they might produce for another thirty or forty years. An orange grove was a long-term investment.

It was not just the growers who benefited from the groves. Oranges meant jobs for the whole community. There were pickers, packers, pruners, fumigators, field hands, sprayers, truckers and many others who worked directly in the citrus industry, while most of the businesses in town relied on the citrus workers as their customers. The 1919 Orange City Directory shows that about one-third of the local workforce was employed in some aspect of the citrus industry.

And don't let those idyllic pictures on the old citrus labels fool you—it was an *industry*, a vast, interconnected enterprise stretching from the local growers all the way up to the massive California Fruit Growers Exchange, better known by its famous trademark: Sunkist.

Harold Brewer (1891–1990) was active in the citrus industry for most of his long life and served as the second president of the Villa Park Orchards

A Growing Community

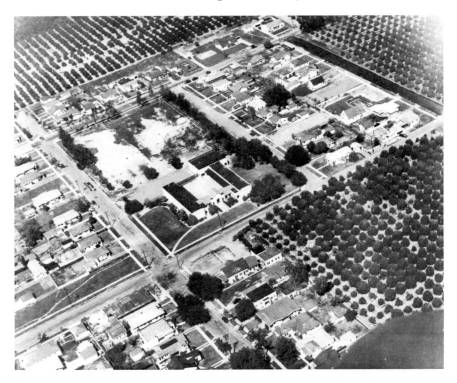

Homes meet orange groves on the edge of downtown, circa 1950. The old Maple Avenue School (now the Covenant Christian Church) is in the center. *Courtesy the Orange Public Library and History Center.*

Association. He could remember the days when growers had to pack their own fruit or sell it to commission agents representing private packinghouses and wholesalers. He recalled in 1985:

> *In the early days, packing and shipping was all done by independents. They would come and either buy your fruit for so much a box—estimating it on the trees—or they would pick it and pack it and pay you so much, with them keeping a commission. And it got to be—if you want it politely—so many robbers. So the growers had to seek a way to defend themselves. That's what started the co-ops. Just like any other business, a group can do business cheaper than a single individual. The picking, hauling, packing—all of these things were much cheaper than having somebody in the business to make a profit do it. Instead, that profit was divided back to the growers.*

Local growers would join together to form a cooperative packinghouse association to build and operate their own packinghouse. These associations would then join larger organizations. The fruit exchanges coordinated sales and shipping of fruit to different parts of the country to secure the best prices. Meanwhile, Sunkist launched vast national marketing campaigns that promoted Southern California almost as much as they touted its golden fruit. "Oranges for Health! California for Wealth!" was one of its slogans. They were joined in 1908 by the Mutual Orange Distributors (MOD), and the American Fruit Growers a decade later, but from the beginning, Sunkist dominated the citrus world.

Orange's first private packinghouse opened in 1883. The first cooperative house was the Santiago Orange Growers Association (SOGA), formed in 1893. The SOGA eventually grew to be the largest Valencia packing operation in the nation. In 1929, its 350 members owned 4,263 acres of citrus, and its packinghouse handled more than 1.4 million thirty-pound field boxes.

Other local packinghouses included the Orange Cooperative Citrus Association, the Orange Mutual Citrus Association (an MOD house) and the Foothill Valencia Growers, which became Red Fox Orchards and then consolidated with the McPherson Heights Citrus Association in 1928 to form Consolidated Orange Growers. Consolidated closed down in 1965, but its old packinghouse still stands on South Cypress (now the home of RWB Party Props).

In all, there were about a dozen packinghouses in and around Orange during the glory days of the citrus industry. There were two packinghouses in Villa Park—Villa Park Orchards Association (founded in 1912) and the Central Lemon Association, which operated from 1912 to 1960. In El Modena, the David Hewes Orange & Lemon Association operated a packinghouse near La Veta Avenue and Esplanade Street until 1940 and leased the building to other packers after that. The old packinghouse finally burned down in 1947.

Olive was also plagued by packinghouse fires. The two big packinghouses there were both organized in 1914—the Olive Heights Citrus Association (a Sunkist house) and Olive Hillside Groves (MOD). In December 1927, the Olive Hillside plant caught fire, and the flames quickly jumped to Olive Heights, destroying both packinghouses. The smaller Olive Fruit Company house burned in 1932. Olive Heights moved across the tracks in 1928 and built a new, concrete packinghouse, which operated until 1984. That building was partially destroyed by fire in 1988 and was finally torn down in 1997.

A Growing Community

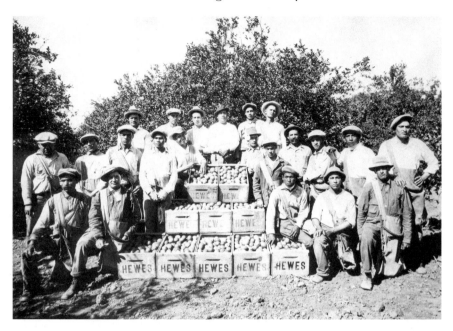

A Mexican American picking crew on the Hewes Ranch in the 1920s. Climbing ladders, they clipped the fruit by hand, filling the bags on their shoulders, which also opened at bottom to empty the fruit into field boxes. The Hewes Ranch ran along the base of the foothills, between El Modena and Tustin, and was one of the largest citrus ranches in the area. *Courtesy the First American Corp.*

The Valencia harvest began each spring, usually in May. Picking crews were sent out by the packinghouses to load the fruit into wooden field boxes. Pickers climbed tall ladders to reach the tops of the trees and carefully cut the stems of the oranges with special blunt clippers. It was precise work. Sal Martinez, who came to Orange with his family in 1919, recalled:

> *They used to deduct you for long stems, short stems, slant stems, a clipper cut, pulling, slack boxes, they'd deduct you a quarter of a cent. They used to pay you every two weeks, so they'd deduct you for all the boxes you had picked during those two weeks. There used to be an inspector, he'd come and inspect you; and they had a state inspector, he'd come about once a month. But the regular house inspector, he'd inspect you six or seven times in that two-week period. Oh, they were strict! If they inspected you once, and you had a bad orange, they counted it for two. The state inspector would inspect all your box, but the house inspector, he only inspected about half, so if he found one bad one it was counted for two.*

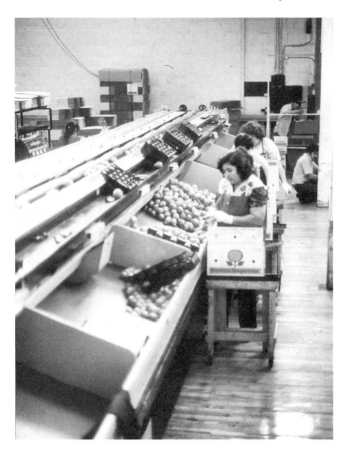

Packing oranges in the old Santiago Orange Growers packinghouse, then operated by Villa Park Orchards, 1982. The original equipment remained in use for decades, and though machines took over more and more of the work in later years, sorting and grading is still done by hand. *Photo by the author.*

Once the fruit was packed in field boxes, it went to the packinghouse. Any ripe fruit that still had a green tint to it was treated with ethylene gas, which gave the skin a healthy orange glow. When it was ready to be packed, the fruit was washed and air-dried. In later years, another machine then added a light coat of wax to protect the skin. Then the fruit rolled down a conveyor belt to the graders, who sorted it for quality and sent the oranges down a series of chutes to the conveyor belts below. Tapered rollers delivered fruit of different sizes to the packers' bins. Then the packers wrapped each orange in a piece of tissue paper and stacked them in neat rows in wooden crates. Once sealed, the crates were sent to a pre-cooler to be chilled before the long train ride to eastern markets.

The colorful labels pasted on the ends of the crates (now a collectors' item) were not seen much by shoppers in the old days. They were designed for the wholesale auction markets in the big cities. The distinctive designs—ranging

A Growing Community

from idyllic scenes in the groves to animals, mythic figures or lovely maidens—allowed bidders to spot each packinghouse's brands from across the crowded auction floor. They knew at a glance the quality of fruit they could expect to find inside. The full-color labels were finally phased out in the mid-1950s as packinghouses switched from wooden crates to cardboard boxes.

The packinghouses paid their growers jointly out of "pools" a few times each season, dividing the profits among them. In between payments, many growers lived on credit with the local stores, their collateral hanging on their trees. When a pool paid out, it meant flush times all around.

There were problems with growing oranges here, however. Citrus fruit is really rather fragile. There are a number of diseases and insect pests that can ruin the fruit, and cold weather is always a danger. To avoid some of the diseases, growers planted sour varieties of oranges and then grafted the Valencia buds onto the sour root stock. Fumigation and oil sprays helped fight parasites and insect pests. And when the temperature threatened to freeze, growers burned oil in smudge pots between the rows to keep the trees warm. The next morning, a black haze would hang over the neighborhood, creeping into houses and leaving a layer of soot on everything. It was not until the 1950s that wind machines replaced the old smudge pots.

Ironically, the sour root stock later proved vulnerable to a new disease, the Quick Decline, which began infecting local groves in the 1940s. Perfectly healthy trees one season would be stone dead the next as the mysterious disease swept through the orchards. In just three years (1959–61), Orange County lost about 300,000 trees to the disease. Where growers in the 1920s might have simply pulled the stumps and replanted, in the 1950s, many chose to sell out to the subdividers and tract home builders who had been pounding on their doors for years, urging them to sell.

One by one, the orange groves disappeared and the local packinghouses shut down. Santiago Orange Growers closed its doors in 1967. Villa Park Orchards bought the old packinghouse two years later and moved all of its operations there in 1978. As the years went on, fruit had to be hauled in from farther and farther away to keep the crew busy. Villa Park's last orange grove was torn out in 1989, and by 1999, there were barely two hundred acres of orange trees left in all of Orange County.

Villa Park Orchards was the last citrus packinghouse to close in Orange County, moving its operations to Ventura County in 2006. Today, the property is owned by Chapman University, and its future is uncertain.

A Brief History of Orange, California

Other Crops and Other Climes

The citrus industry was largely responsible for the many Mexican immigrants who began to move here in the early 1900s. Many came to *los estados del norte* to escape the violence of the Mexican Revolution, which began in 1910. Later, their friends and families followed, all hoping to find a better life. Many men and women found seasonal jobs in the citrus industry as pickers and packers. Some of them worked for the same packinghouse year after year for decades.

During World War II, many Mexican Americans joined the military or found work in the defense plants. In 1943, the Bracero program was established to allow Mexican workers to come north to supplement the local labor force. Later in the war, Filipinos and even German prisoners of war were sometimes brought in to work in the groves.

By 1920, a Mexican *barrio* (neighborhood) had grown up along North Cypress Street. Many of the families that settled there came from the central plateau of Mexico—the states of Jalisco, Michoacan and Zacatecas. There were a number of stores in the Cypress Barrio in the early days. Simon Luna

The Orange Friendly Center began as a Methodist church, built in 1924 to serve the growing Mexican American population along North Cypress Street. In the 1950s, it became a community resource center. In 1985, it moved to its current location in Killefer Park. The original church, shown here in 1982, still stands at 424 North Cypress. *Photo by the author.*

A Growing Community

had his grocery store at 418 North Cypress for decades. A few doors down was the Mexican Friendly Center, which was built in 1924 as a Methodist church to serve the Spanish-speaking community there. In 1956, the building became a community center, providing social services to the area. In 1985, the Friendly Center moved to its current location at Killefer Park. By any standard, the Cypress Barrio was poor. As late as the 1930s, there were still dirt streets there and no sidewalks, and water—sometimes hauled from outside standpipes—was heated over scrap-wood fires. But the sense of community was strong and survives to this day.

El Modena also became home to several barrios in the early twentieth century. The best known was La Paloma, along the foothills on the east side of South Hewes Street. Locals jokingly called it the "Mexican Beverly Hills." It was one of a number of subdivisions laid out in the 1920s to cater to the county's growing Mexican American population.

Both the Methodists and the Catholics established Spanish-language ministries in town. La Purisima Catholic Church dates back to the mid-1920s, though as early as 1909, visiting priests sometimes held Mass in El Modena. In 1927, a sanctuary was built on Center Street, and priests from Santa Ana and the Mexican barrio at Delhi served the congregation for years. It was not until 1957 that La Purisima was granted its first resident priest. Today, it is a large and active congregation with a fine new sanctuary.

While citrus reigned supreme in and around Orange, other crops also proved successful. Apricots were popular up until World War I. There were no packinghouses; most of the crop was cut, pitted and dried on the ranches, right next to the groves. Then the dried fruit could be shipped most anywhere—even to Europe. Later, most of the trees were replaced by oranges.

There were enough walnut growers locally to support two packinghouses: the cooperative Richland Walnut Association (formed in 1919) and Rosenberg Brothers, a private packinghouse. The Richland Association was a member of the California Walnut Growers Association and marketed its crop under the Blue Diamond label. In 1919, Richland's members owned 650 acres of walnuts; by 1940, most of the local groves were gone.

Avocados were a late arrival. The first local plantings began about 1910. Charles P. Taft (the namesake of Taft Avenue) was one of the leading growers and even developed his own variety, known as the Taft Avocado. The trees did well here, but it took years to develop a market for the unusual fruit. A few local groves survived into the 1960s.

Along with the citrus industry, Orange did have some actual industry as well. Electrical cable, rope and twine and even kitchen towels were all

Anaconda Wire & Cable Company was Orange's biggest factory for decades. Originally founded as the California Wire & Cable Co., it was bought out by Anaconda in 1930 and survived until 1982. Its glass-walled offices, built in 1954, still stand at 303 West Palm. *Courtesy the Orange Public Library and History Center.*

manufactured here in factories scattered along the railroad tracks on the west side of downtown. The biggest factory was Anaconda Wire & Cable, which began in 1921 as the California Wire & Cable Company and was bought out by the Great Anaconda Copper Mining Company in 1930 in an effort to expand its control of the market. At its peak in the early 1950s, Anaconda employed about three hundred people, including many residents of the Cypress Barrio. As late as 1973, Anaconda was still the fourth-largest industrial employer in Orange, but by 1982, the firm had closed its doors. Anaconda's plant, warehouses and offices were spread across more than twelve acres east of the tracks. Chapman University's film school covers part of the site today, and the university has recently announced plans to renovate some of the other old buildings.

The Great Western Cordage Company began in 1923, making manila rope in a plant along the west side of the Santa Fe tracks, just north of Palm Avenue. In 1947, the factory was bought out by the Tubbs Cordage Company, one of the largest rope-making firms on the West Coast. They

A Growing Community

operated the plant until 1986. It was reopened briefly as Tubbs Rope Works, which moved to Arizona in 1991, where it is still in business today. Chapman University bought the old buildings in 1999 and has renovated them for offices and classrooms.

ORANGE UNION HIGH SCHOOL

In the 1890s, the few students from Orange who wanted to continue on to high school had to go Santa Ana, some of them riding the streetcar back and forth each day. In 1891, a proposal for a single county high school in Santa Ana was defeated by local voters, and each community was left to fend for itself. But by 1900, only Santa Ana, Fullerton and Anaheim could boast their own high schools.

Orange Union High School joined the quartet in 1903. A "union" high school was a separate school district that served a number of smaller elementary school districts. The Orange, Olive, El Modena and Villa Park school districts were all part of the Orange Union High School District. Later, Silverado was added to the list. A few students from Tustin also attended OUHS until they got their own high school in 1921.

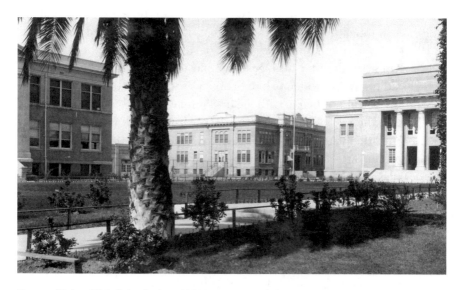

Orange Union High School, circa 1925—now part of the campus of Chapman University. The original building is in the center. Built in 1905, it was moved to its current location in 1923, when the Memorial Auditorium (right) was completed. *Courtesy Tom Pulley.*

A Brief History of Orange, California

Orange High started small in 1903, with just four teachers and eighty-six students in rented rooms in the 100 block of South Glassell. Recess was held out in the street or in the vacant lots around downtown, and the clanging of the hammers at the blacksmith shop on the corner would sometimes interrupt lectures. But the school did its best to offer a full program; it even fielded a football team that first fall.

The school spent two years in its downtown classrooms. There were no graduates in 1904, but seven seniors received their diplomas in June 1905. That fall, Orange High moved to its own building at the northeast corner of Glassell Street and Palm Avenue. It was two stories, with a full basement that doubled as a gymnasium. The building had a study hall, classrooms, offices and a stable out back for the students who rode their horses to school each day.

The curriculum was largely academic back then, with few electives. But music, drama and athletics were always a part of the school year. The school had its own band by 1907, and the senior class play was a big event each spring. Another highlight, beginning in 1920, was the annual faculty play, which raised money for scholarships. Nita Walton, a 1917 OUHS graduate who returned to teach on campus from 1922 to 1958, later recalled, "Sometimes we'd put on a play for three nights in a row and we'd fill the auditorium! We had a good time. Our teaching didn't amount to much for a while, but it was lots of fun to put on a play and we raised several thousand dollars."

Basketball and track were Orange's big sports in the early days (football, sadly, not so much). The school's first great track star was Fred Kelly (class of 1911), who went on to win the gold medal in the 110-meter hurdles at the 1912 Olympics—the first Orange Countian to bring home the gold. The district stadium at El Modena High School was named in his honor in 1969.

School publications began with the first annual in 1906, and the launch of *The Reflector*, the school newspaper, in 1916. Historian Don Meadows (class of 1917) was the first editor.

The campus was built building by building over the course of more than two decades. The original classroom building was joined by two matching buildings on either side in 1913 (commonly known as "The Twins"). A shop building went up in 1917 and a gym (now gone) in 1926.

The biggest project was in 1923, when an auditorium was built right behind the original building. That summer, the first building was picked up, moved, turned sideways and placed in its current location. Most of the basement was filled in, giving Orange Union High School a sunken lawn in the center of campus. The last of the original buildings—the art and cafeteria building—was completed in 1928.

A Growing Community

Every school has its traditions; at Orange Union High, O-Day and Dutch-Irish Days were the highlights of the year for generations of students. O-Day was inaugurated by the class of 1917. Shortly before graduation, they announced that they were skipping school for a day to go up to the hills east of town to carve a giant "O" into the hillsides. They staked it out, cleared off the brush and painted it white for all to see. Cleaning the O was a more or less annual tradition for the next four decades. There was always food, comic costumes and, of course, no classes. The O moved several times during those years; originally it was above Villa Park, and later it was near the top of the El Modena Grade, above Chapman Avenue.

The start of Dutch-Irish Days is not as well documented. It seems to have begun about 1928 as an intramural basketball game to settle some old scores. Before coming to Orange High, many of the players had been on opposing teams from the Orange Intermediate School and St. John's Lutheran School. Apparently, Coach Hod Chambers got tired of hearing them bickering about who had the better team and proposed a grudge match just to shut them up. The Dutch (from St. John's) would play the Irish (why he chose Irish no one ever seemed to remember). The first recorded game was in 1929, when the Irish beat the Dutch, 17–12.

Before long, everyone was taking sides. Cheerleaders were selected, and fans crowded the gymnasium to watch. Before World War II came along, the Dutch (Deutsch) were Germans, wearing red and white and even hoisting megaphones with beer steins painted on the sides. But with war approaching, the Dutch switched from Germany to Holland, with wooden shoes and red tulips. The Irish, of course, wore green and sported shamrocks.

Dutch-Irish Days grew into an entire week of celebrations, costume days and pep rallies on campus. But by the 1960s, some students began to use the event as an excuse to go wild, roaming through the streets of town and vandalizing property. In 1964, Principal Verrill Townsend warned the students that if they didn't clean up their act, he'd shut the whole thing down. Sadly, 1965 came as wild as ever, and Townsend was good to his word. It was the last year of Dutch-Irish. The Spirit Week that later replaced it has never generated the same energy or devotion.

Newfangled Notions

In the first few decades of the twentieth century, Orange's pioneer days faded away, and modern amenities began to appear. In 1904, the city

A Brief History of Orange, California

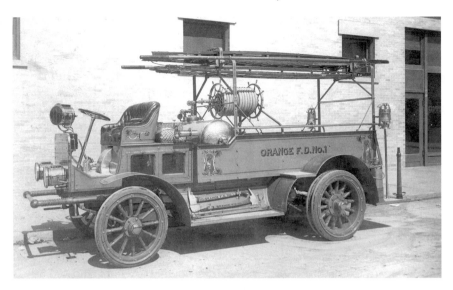

The Orange Volunteer Fire Department got its first motorized truck in 1912. The Seagraves pumper was later sold to another city, but it was destroyed when its fire station burned down. *Courtesy the Orange County Archives.*

bought out the private Orange City Water Company and formed a Water Department. The first sewers in town were built following the passage of a bond act in 1911. The first telephone switchboard was installed in 1903. Two telephone companies—Sunset Telephone & Telegraph and the Home Telephone Company—offered local service in the 1910s. The two systems were completely separate, and businessmen had to have two different phones (and two different phone numbers) if they wanted all of their customers to be able to call them. A series of mergers finally created the Pacific Telephone & Telegraph Company in 1919.

The Orange Fire Department began as a volunteer crew in 1905, with some support from the city. It bought its first motorized fire truck in 1912, the same year the city hired its first fire chief. Bit by bit, the paid crews took over, but it was not until 1966 that the last of the old volunteers retired.

The Orange Public Library got a new home in 1908, courtesy of a $10,000 donation from the Andrew Carnegie Foundation, which built libraries all across the United States. The Classical Revival–style building on the northeast corner of Chapman Avenue and Center Street stood until 1960.

Orange had been a city for thirty-three years before it finally got a proper city hall. Since 1888, the city offices had bounced around from one downtown

A Growing Community

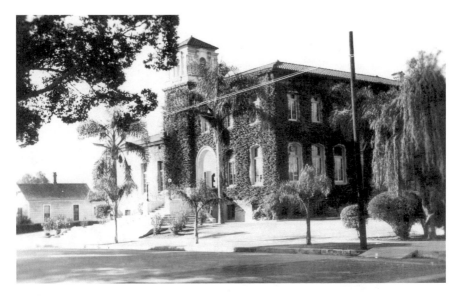

Orange's city offices moved from one downtown building to another for more than thirty years until this Spanish-style city hall was built in 1921. Shown here in the 1940s, it stood until 1963. The city council chambers now occupy the site. *Author's collection.*

building to another, renting space as needed. Finally, in 1921, a two-story, Spanish-style city hall was built at the southwest corner of Chapman Avenue and Center Street—the site of the city council chambers today. All of the city departments had their offices there except for the fire department; there was even a jail downstairs.

As automobiles became more common, the need for better roads became apparent. A car without a paved road simply wasn't much use. That gave birth to the national Good Roads Movement, which pushed for the paving of local streets and county roads and led to the establishment of the first state highway through Orange County in 1914. The Santa Ana Freeway follows much of its old route today, but the original state highway also made a number of twists and turns to pass through some of the larger local communities. Coming down from Anaheim, the state highway turned east on West Chapman down to Main Street, where it turned south to Santa Ana. A little business district soon grew up at the corner of Chapman and Main that catered mostly to the highway trade, with gas stations, a garage and a store. Folks called it Orana, since it was midway between Orange and Santa Ana.

A little farther south, St. Joseph Hospital was another landmark along the old state highway. The Sisters of St. Joseph were originally a teaching order,

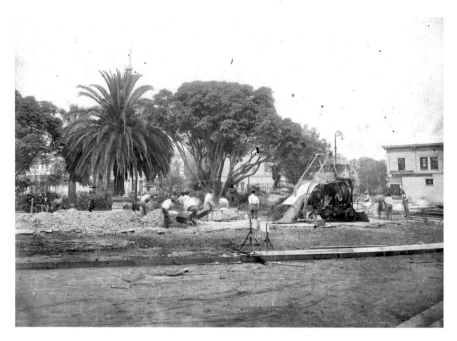

Naturally, the Plaza Square was the first street to be paved in Orange in 1912. From there, the concrete pavement was extended outward through downtown. One local woman claimed the contractor was cheating the city by not pouring enough cement and even dug up the street in front of her home to prove it. She didn't and got sued by the contractor for her troubles. *Author's collection.*

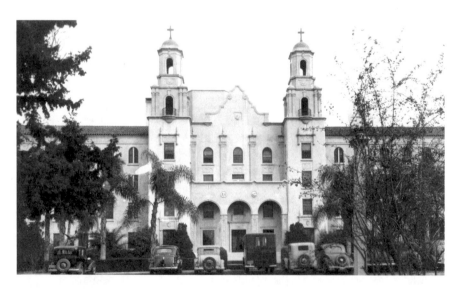

St. Joseph Hospital was the finest hospital in Orange County when it opened in 1929. The original building is now used for offices. *Courtesy Tom Pulley.*

but they added nursing to their ministry during the influenza epidemic following World War I. They came to Orange in 1922, purchasing the old Burnham estate at Batavia Street and La Veta Avenue. For many years, the Burnham home served as their motherhouse, and they even continued to grow oranges on the property to provide a little extra income.

But the sisters had bigger dreams. In September 1929, they completed the first modern hospital in Orange County, a four-story Spanish-style building with 150 beds (that original building is still used for offices today). A nursing school was opened in conjunction with the hospital, and a number of local doctors joined St. Joseph Hospital as staff physicians. Until 1971, members of the order served as the hospital administrators.

In 1964, the sisters completed construction of a new, 290-bed hospital. A north wing was added in 1976. In 1981, the sisters formed the St. Joseph Health System, which currently owns and operates fifteen hospitals in California, Texas and New Mexico.

The success of St. Joseph Hospital attracted many other healthcare facilities to the area around Main and La Veta. One of the most prominent is the Children's Hospital of Orange County (CHOC), which opened its own hospital next door to St. Joseph Hospital in 1964. It has been growing rapidly in recent years and is currently building a new facility, scheduled to open in 2013. St. Joseph Hospital has continued to grow as well, adding a new Patient Care Center in 2007 and a new Cancer Center two years later. Today, our three local hospitals—St. Joseph, CHOC and UCI Medical Center—are Orange's largest employers, with some eleven thousand employees between them.

The Fourth Estate

In the days before radio and television, even many small towns could boast their own local newspaper. El Modena had the *Record* in the boom days of 1888, and Olive had its own paper in 1925.

Orange's first local paper, the *Orange Tribune*, began publication in April 1885. Editor and publisher Bill Ward was a longtime California newspaperman and a colorful figure. One of his old partners later recalled:

> *Big, generous hearted, free-and-easy "Bill" Ward was surely a "character"—a typical Californian who didn't have much use for new-fangled Eastern ideas of things in general. He believed that water was*

intended solely for irrigation, laveing, and culinary purposes, and that tobacco was a staple article of food. He lived for the joy of living, and if he ever had a thought or care for man's future state it was most effectually concealed beneath an exterior of jovial good humor. Ward was a writer of no mean ability, as full of fun as a circus clown and a wit by nature.

Ward was a cautious believer in the real estate boom of the 1880s and sold out at the end of 1887, as the boom began to go bust. The new publisher, Fred Clemons, was an ardent boomer, but his enthusiasm couldn't carry him through the dull times that followed the crash. He leased the *Tribune* to a pair of eager young newsmen in March 1889 and set out in search of greener pastures.

Leslie Woodruff and Ulysses Sidney Lemon (known to his friends as Sid) struggled on until the summer of 1889. It didn't help that the *Tribune* got a competitor in December 1888, when James Fullerton launched the weekly *Orange News*. In August, Woodruff and Lemon gave up the *Tribune*, and a week later, Woodruff started fresh with a new paper, the *Orange Post*. The *Post* didn't even have its own printing press at first; the type was hauled off to Santa Ana each week for printing.

Fortunately, in those days of handset type, you didn't have to fill a whole newspaper every week. Publishers could buy pre-printed pages, already full of generic national news, random features and assorted advertising. You could even order them with your own masthead printed on the first page. These "patent" pages (jokingly called "boiler plate") were part of what made it possible for all those little towns to have their own papers.

The *Orange Post* continued to struggle for the next few years, changing publishers several times. Alice Armor, a local schoolteacher, was hired as a bookkeeper and proofreader and eventually ended up writing for the paper as well. She survived several changes in management before buying the paper herself in 1892. She would serve as editor and publisher for the next twenty-three years.

Alice Armor was a beloved figure around town, and her newspaper reflected her interests—churches, schools, social organizations, temperance and women's suffrage. Pioneer passings always rated long obituaries. Local businesses, on the other hand, got little space in the columns of the *Post*.

Her husband, Sam Armor, was—as historian Don Meadows liked to say—a little man who wanted to be big. He was exasperatingly slow in thought and speech, and his endless editorials and lengthy letters to the editor (not just in the *Orange Post* but in papers throughout Orange County) are wordy

and convoluted. Yet he was a successful politician, serving as our first county supervisor after Orange County was formed in 1889 and then as mayor of Orange and president of the Santa Ana Valley Irrigation Company.

James Fullerton took special pleasure in baiting Sam Armor in his editorial columns at the *Orange News* and clearly knew how to push all of Sam's buttons. Armor could always be counted on to reply in sputtering rage. It made for good copy for both papers. Yet when the two met on the street, you would never have known there was any bad blood between them; certainly Fullerton never took the battles personally.

In those days of thoroughly partisan newspapers, the *Orange Post* backed a straight Republican ticket. The *Orange News* billed itself as "independent," which in this case meant a Democrat-leaning paper in a Republican town. It was said that some of the prominent local Democrats helped put up the money for Fullerton's new venture to give their party a voice in local affairs.

In 1906, after eighteen years in the editor's chair, James Fullerton decided to retire from the newspaper business. He sold the *Orange News* to George Wright and Charles Meadows. Meadows was a printer for the *Orange Post*, and Wright was a former Kansas newspaperman. But the partnership was short-lived. There simply wasn't enough money coming in to support two men and their families. And there were political differences as well—Meadows was a Republican, while Wright was a staunch Democrat. Finally, in May 1907, the partners agreed to flip a coin to decide who would stay and who would go.

"Dad always said he won," Charles's son, Don Meadows, used to chuckle—Wright had to buy him out.

Wright pushed on and even published a letter sheet–sized daily edition now and then, though regular publication of the *Orange Daily News* didn't begin until April 1908. To help meet the daily deadlines, Wright hired a new reporter named William O. Hart. In 1909, Hart and his longtime friend Justus Craemer bought out the *Orange Daily News*.

Over the next thirty years, Hart and Craemer—and their newspaper—played an important role in the development of Orange. Hart was calm, contemplative and a powerful writer. Craemer was fiery, opinionated and an aggressive businessman. Together, they made an unbeatable team. Every politician (and not just the Republicans) wanted their endorsement—not only for races in Orange but almost anywhere in Orange County. Craemer also became a force in state Republican politics, serving for many years on the powerful State Railroad Commission (the predecessor to today's Public Utilities Commission).

A Brief History of Orange, California

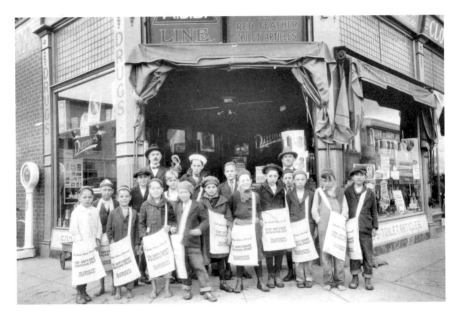

A group of "newsies" gathers outside Dittmer's Drug Store about 1920, ready to make their rounds delivering the *Saturday Evening Post*, the *Ladies' Home Journal* and the *Country Gentleman*. Druggist Adolph Dittmer is behind them on the left. The building (remodeled in the 1930s) still stands at 101 South Glassell. *Courtesy the Orange Public Library and History Center.*

Locally, the *Orange Daily News* led the drive for civic improvements such as paved streets and sewers. In 1919, Hart and Craemer were able to buy out the old *Orange Post*. They kept it running as a weekly until 1946 to help keep other possible competitors at bay (and to pick up those national advertisers that weren't interested in buying ads in little local dailies).

But most of all, the *Orange Daily News* covered the community—local businesses, local organizations, local schools, local churches, local sports and, most of all, local folks. Weddings, birth announcements, vacations, parties, housewarmings and obituaries filled the columns of the paper day by day. There was national and state news on page one, of course, but everyone knew the heart of the local news was on Amy Palmiter's society page inside.

The fortunes of the *Orange Daily News* changed suddenly in December 1942, when Bill Hart was killed in an airline crash. To add to the tragedy, his son, Bill Hart Jr., was killed in a military plane crash the very next day while on his way home for his father's funeral. Their joint memorial service was probably the biggest funeral Orange has ever seen.

Bill Hart's son-in-law, Ranald Fairbairn, was brought in by the family to take over as publisher, and with most of the old team in place, kept the *Orange*

Daily News strong until after World War II, when costs began to rise (newsprint was hard to come by at any cost in those postwar days) and competition from outside media increased. In 1953, the family finally decided to sell the paper. It was the beginning of the end for the *Orange Daily News*.

The paper's new owner, Charles Voigt, brought a big-time, metropolitan paper sensibility to the old *Orange Daily News* that didn't fit well with the local community. Orange was changing in the 1950s, but most readers still weren't looking for screaming headlines and bloody car crash photos in their local paper. After another change of ownership, in 1964 the *Orange Daily News* was bought out by the *Santa Ana Register*, which was busy trying to sew up the Orange County newspaper market by buying out all its competition. Everyone knew it was just a matter of time until the *Orange Daily News* fell to the *Register*'s aspirations. The *News* was reduced to weekly in 1967 and shut down in July 1968 after sixty years of daily publication.

In 1969, the weekly *Orange City News* was founded to try to fill the void left by the death of the *Daily News*. The *City News* had a checkered career financially, and it, too, was eventually bought out by the *Register*. It continues today as one of its many local weekly editions.

Downtown Landmarks

Downtown Orange as we know it today was largely in place by 1930. Some of the buildings wear new façades, and a few modern buildings have been wedged in between, but there are many old landmark buildings here that have survived virtually unchanged over the decades.

The Ainsworth Block (100–08 West Chapman) is actually two buildings in one. The lower floor, along the Plaza Square, was built in 1888 by Sam Armor as his book and shoe store. The iron columns dated 1888 are still in place beside the doors. In 1901, when Armor closed his store, Lewis Ainsworth bought the building as an investment. In 1907, he expanded the old building, tripling its footprint and adding a second story to give us the building we see today.

The Ainsworth family owned the building until 1946, leasing space to a number of small businesses and professional offices, including Meyers Millinery, the Southern California Edison Company and the Plaza Barber Shop, where Archie Ford, Orange's only black businessman in the early days, operated his shoeshine stand in the 1930s. Samuel Hurwitz moved his law practice here in 1943 and was later joined by his son Mark. The firm of Hurwitz & Hurwitz still occupies the corner to this day.

A Brief History of Orange, California

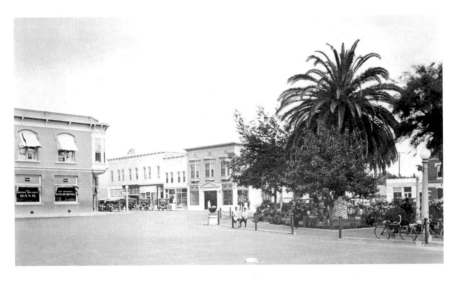

Downtown Orange, circa 1920. The original Bank of Orange building is on the left; Wells-Fargo is on the corner today. The three buildings on the other side of East Chapman still stand under different façades. *Courtesy the First American Corp.*

The stories of two of our downtown buildings are linked in an unusual way. In 1900, the Independent Order of Odd Fellows (IOOF) began construction of its own building at 112–20 East Chapman. It would have three storefronts downstairs and a lodge room and other facilities above. It wasn't unusual for fraternal organizations to take on a project like this back then. It was a way to help build up their community and have a nice place to meet besides, with rent from the stores below helping to pay for it all. Completed in 1901, one of the first tenants of the Odd Fellows hall was Watson's Drug Store, which is still there today.

Twenty years later, with the mortgage finally paid off, the Odd Fellows began thinking about an even bigger project. They bought the land cattycorner across Chapman Avenue and in 1925 built a new three-story building, the tallest in downtown Orange. Once again, there were storefronts on the ground floor (two on East Chapman, two on North Orange) and two floors of space above for the Odd Fellows to meet.

That left the old Odd Fellows rooms across the street vacant. Kellar Watson Sr. bought the building from the lodge, and in 1929, he finally found a new tenant—the local Elks Lodge. The Orange lodge of the Benevolent and Protective Order of Elks was one of the newest organizations in town, first chartered in 1923. It attracted many of the younger civic leaders and businessmen and soon grew into a prominent force in the community.

A Growing Community

The Odd Fellows, on the other hand, were sinking. Worse, they had trouble finding tenants for their new building. When the Depression hit, they found themselves deeply in debt and eventually lost their new home to the bank.

For the Elks, the foreclosure was a golden opportunity. In 1934, they arranged to rent the new Odd Fellows hall and were able to buy it for a song a few years later. Meanwhile, Kellar Watson took pity on the Odd Fellows and let them rent their old hall above his store for a nominal fee. The Odd Fellows had faded away by the 1960s, but the Elks remain active in the community to this day.

The Campbell Block at 101-7 South Glassell was built in 1901—but you wouldn't know it to look at it today. Originally, it was a red brick building with an unusual rounded second-story turret over the entrance (even the double-hung windows were curved). But about 1938, the turret was cut off, the brick was plastered over and the whole building was given a slick art moderne façade that was up-to-date for its day but now seems old-fashioned to us.

This prime Plaza corner was home to Dittmer's Mission Pharmacy for thirty years (1908-38). Radio Shack has been on the corner for the last forty years or so—the last national retail chain with a store in downtown Orange.

The Edwards Block (101-23 North Glassell) was built in 1905 by N.T. Edwards (later our state senator) and D.C. Pixley. Edwards had his meat market at 105 North Glassell. The Pixley Furniture Store was at the other end of the building at 123 North Glassell. Later run by D.C.'s son, Walter Pixley, the furniture store survived into the late 1930s.

The building was designed by C.B. Bradshaw, Orange's first resident architect, and built by N.U. Potter. Both men were responsible for many of the landmark buildings in downtown Orange. In 1915, Potter built an addition to the rear of the building, along the Plaza Square, that added two more storefronts below and a suite of professional offices above.

There were many long-term tenants of the Edwards Block. Weaver's Book Store (later Carey Stationers) was at 109 North Glassell from 1917 into the 1960s, the Cornet 5 & 10¢ store was on the corner for almost thirty years beginning in 1945 and there was a barbershop at 115 North Glassell for more than half a century. Upstairs, the Edwards Block offered both a public hall (used by the Masons before they moved across the street) and hotel rooms, which were later converted to apartments.

The Jorn Building was also built in two stages. The eastern half was built in 1908 on the last vacant corner around the Plaza Square (101-7 West Chapman), but the western half (109-29 West Chapman) wasn't added until 1924. In fact, a recent remodel revealed old advertising murals that had

been painted on the west side of the original building but are now inside one of the stores in the newer wing.

Carl Jorn had his insurance agency upstairs in the original building until about 1930. Western Auto was below on the corner from 1924 to 1943, and then Hockaday & Phillips, an Orange County auto parts chain, moved in. The newer portion of the Jorn Building housed a dry cleaner, a small restaurant, a liquor store and a variety of offices upstairs. On the Plaza side, the city leased office space at 55 Plaza Square from 1908 to 1916. (With no city hall until 1921, the city rented space in a number of downtown store buildings over the years.)

The west side of South Glassell boasts three of downtown Orange's landmark buildings. The Cuddeback Building (100 South Glassell) occupies the corner where Orange's first hotel was built in 1875. It was torn down in 1905, and the Cuddeback Building was built that same year, with storefronts below and apartments above. The building has been home to many local businesses (Huff's Jewelry occupied the corner store for more than thirty years) and also briefly served as city hall (1907–8). The city had two rooms on the Plaza side of the building at 30 Plaza Square.

The biggest building in downtown Orange is the old Ehlen & Grote Block. It stretches for two stories from 108 to 126 South Glassell and then

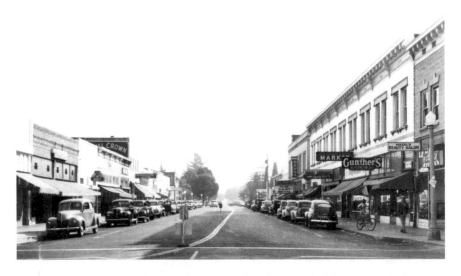

Looking down South Glassell, probably in 1946. The first four businesses on the right are a barbershop, Gunther's Clothing Store, a grocery store and Orange Hardware. Shoppers could find almost everything they needed in downtown Orange in those days; a big shopping trip meant going all the way to Santa Ana. *Courtesy Tom Pulley.*

wraps around the Cuddeback Block to provide two more storefronts at 40–42 Plaza Square.

Ehlen & Grote were Orange's biggest retailers in the early 1900s. Founded in 1889 as a grocery store by P.W. Ehlen and Henry Grote, the firm later expanded to include clothing, shoes, hardware, appliances, housewares and more. For ranchers who couldn't make it into downtown every day, they also offered a delivery service, with their sales wagons stopping by ranches a couple of times a week to take orders or deliver the goods.

After occupying several smaller locations, the firm built its own building in 1908. Ehlen & Grote took up almost the entire ground floor along South Glassell, along with the basement, and still operated another small grocery store across the street to boot. Then as now, the second story of "the big white store" was used for apartments.

But the coming of the Depression and the rise of the chain stores hit Ehlen & Grote hard. After several rough years, the store finally closed in 1938. It had already sold off its hardware line, which continued under new owners as Orange Hardware into the 1970s at 118 South Glassell. Gunther's Clothing had the storefront at 110 South Glassell for more than forty years before finally closing in 1972.

Across the Plaza Alley from Ehlen & Grote's is the Smith & Grote Building—better known today as the Friedemann Building (132–40 South Glassell). It was built in 1914 by A.R. Smith, a manager at the Ehlen & Grote store, and Fred Grote, a son of co-founder Henry Grote. The hall upstairs was originally home to the Orange Commercial Club, which became the basis of the Elks Lodge, and was then briefly used by the Odd Fellows. When Richard Friedemann bought the building in 1945, the local chapter of the Veterans of Foreign Wars was meeting there.

Downstairs, the best-known tenant was Harms Drug Store, which operated at 136 South Glassell from 1917 to 1949. Like Watson's Drug Store, it also featured a lunch counter. It was a popular stop for moviegoers on their way to and from the Colonial Theatre (later renamed the Plaza Theatre). The Colonial was the first movie house in Orange actually built as a theatre. It was a single-story wing in the rear of the Smith & Grote Building. In later years, it was eclipsed by the glitzier Orange Theatre and turned to second-run pictures and late-night B movies. It was torn down in 1958.

The Masonic Temple at 100–8 North Glassell was originally known as Campbell's Opera House, though it's unclear if anyone ever sang a note of opera there. Local investor C.B. Campbell had the corner cleared in 1909, tearing down the original Fischer Brothers store and several other rickety old

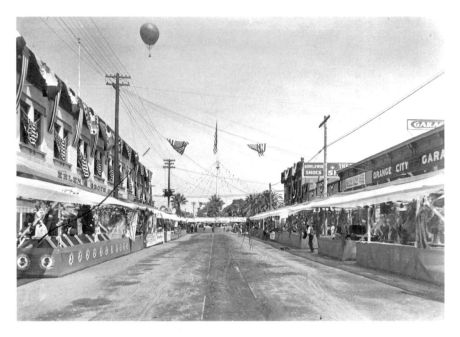

The 1910 street fair in Orange took the place of a county fair. It featured booths with displays from local businesses and farmers, a chicken-judging contest, sideshows, band concerts and a captive balloon that took stout-hearted visitors hundreds of feet into the sky. Here is the view on South Glassell Street during the three-day celebration. *Author's collection.*

wooden buildings. Construction soon began on the opera house but stalled after a few months, and it was not until 1912 that Campbell was able to complete the project at a cost of $26,000.

The downstairs storefronts (two on North Glassell, one on the Plaza Square) were home to a variety of businesses over the years, including the Den o' Sweets (a popular candy shop in the days around World War I), two more of Orange's many downtown drugstores (Simon's and then Marsh's) and the First Commercial Bank of Orange, which was later bought out by the Bank of Italy, which soon changed its name to Bank of America (both names are still visible today on the old painted advertising mural on the north side of the building). For the last forty years there has been a beauty college on the corner, operating under a variety of different names.

The hall upstairs could originally seat 150 people. It was used for a variety of local shows and community events, including high school graduations and concerts. The Orange Grove Masonic Lodge (founded in 1888) bought the building in 1923 and remodeled the second story to meet their needs. They have been meeting there ever since.

A Growing Community

The Kogler-Franzen Block (131–43 North Glassell) went up in 1916, primarily as a home for the Kogler Hardware Company. The Kogler bothers (Paul and Will, sons of St. John's founding pastor, Jacob Kogler) bought out D.C. Pixley's hardware line in 1908 and, along with their brother Henry, ran the business until 1943, when they sold out to Western Auto Stores. Paul Kogler stayed on to run the hardware department for the first few years. Besides auto supplies and hardware, Western later expanded its line to include housewares, furniture, men's and women's clothing and even toys for the kiddies. When Western closed up in 1958, JCPenney moved in to its old location. Penney's left downtown in 1974 after opening a new store at The City Shopping Center.

For the Franzen family, the building was strictly an investment, and they owned it for more than thirty-five years, renting out the storefronts on the north end of the building. Longtime tenants included the Orange Paint Store, which opened in 1936, and Orange Camera (1951–2004).

There has been a bank at 101 East Chapman for 125 years. Orange's first bank, known simply as the Bank of Orange, built its offices here in 1887. Despite its name, the bank was largely owned by Santa Ana businessmen, with just a few token board members from Orange. In 1905, a group of

The First National Bank of Orange built its impressive Classical Revival offices at 100 East Chapman in 1928. The building was designed by prominent Los Angeles architects Morgan, Walls & Clements, best known for the old Uniroyal tire factory along the I-5 in the city of Commerce—now the Citadel outlet mall. Shown here in the early 1950s, the bank sold out to Wells-Fargo in 1977, which still has offices on the corner. *Author's collection.*

local investors bought out almost all the stock of the old bank and founded a second local bank, the First National Bank of Orange. They kept both institutions going until 1927, when they finally merged the old Bank of Orange into First National.

That's when construction began on the new offices on the old site. Los Angeles architects Morgan, Walls & Clements designed a substantial, Classical-style building. Before tearing down the old 1887 building, the bank built a temporary office at 20 Plaza Square. Later, it would become the home of the Orange Building & Loan Association; for the past fifty years, it has housed the Assistance League thrift shop.

The new First National Bank of Orange was completed in June 1928 and still dominates the east side of the Plaza Square. In 1955, a modern addition was added along East Chapman. That same year, the bank got approval for its first branch office, at Tustin Street and Collins Avenue. In 1963, the downtown office was extended to Orange Street, and the bank changed its name to the First National Bank of Orange County. Eventually, it had eleven branches scattered around Orange County.

But by the 1970s, it was obvious that First National was eventually going to be bought out by some larger financial institution. Hoping for a little choice in the matter, the directors agreed to merge with Wells Fargo in 1978. First National's offices all became branches of Wells Fargo, and it has occupied this landmark corner ever since.

Like Campbell's Opera House, the Orange Theatre (172 North Glassell) had a tough time getting built. The empty corner at Glassell Street and Maple Avenue had been used for horseshoe pits for many years. Harry Adams rounded up a group of investors and started construction of a modern motion picture theatre here in 1924, but the money soon dried up, leaving the unfinished building as nothing more than an empty concrete shell. After three years, Michael Eltiste, who had the International Harvester dealership across the street, decided enough was enough and announced plans to complete the job. Some folks laughed and called it "Eltiste's Folly," but Eltiste saw it through, and the Orange Theatre opened in May 1929, complete with seating for 1,100 and a sound system for the newfangled talking pictures.

While Eltiste owned the building, the theatre was leased to a string of theatre chains. The theatre also has a full stage, which was sometimes used for vaudeville shows in the early days and later for local live theatre. By 1974, it had closed as a motion picture theatre, and after a failed attempt to convert it to a professional playhouse, the old building was acquired by the Son Light Christian Center, which has held services there since 1976.

A Growing Community

A Business Pioneer

George Woods watched the progress of downtown Orange from his dry goods store at 101 North Glassell for a quarter of a century. In 1927, a reporter from the *Orange Daily News* came to ask him about the changes he'd seen around town over the years, and he clearly enjoyed the opportunity to play the role of old-timer:

> *Twenty-one years since we came to town. We held our twentieth business anniversary last fall, you remember. Now I fancy you would be somewhat surprised at the way things looked in Orange even so recently as twenty-one years ago.*
>
> *I remember that when we first moved into this street, up at the intersection there of Orange and Washington streets was a little plaza—a small circle holding a palm and some grass, and that from Center Street School* [at Center and Culver] *and on, all was orange groves.*
>
> *As far as the Plaza business center, I recall the remark of a lady—a tourist—as she stood in the Plaza park and looked around the circle:*
>
> *"Why, this seems just like a jail—all blank walls!"*
>
> *And it was true. There was not a square foot of plate glass anywhere—no show windows in a single building facing the Plaza.*
>
> *Among my business contemporaries of that time were A.H. Bibber who had a dry goods store where the First National Bank now stands* [101 East Chapman]. *Mr. Hallman—Hallman and Field—occupied the location of Watson's present store* [120 East Chapman]*—dry goods on one side—groceries on the other. Where the Masonic building now stands was a frame store building housing a second hand store. During a flush of prosperity the old building was torn down and the basement of a new building was built. That was as far as the enterprise went for several years—a basement filled with rainwater during the winter storms…*
>
> *The newspapers of the time were run by Alice Armor of the* Post *and George Wright who later started the first daily in Orange. When he first began to talk about a daily paper I was one of those who couldn't somehow see it.*
>
> *News was so scarce in those days that when they began the project of moving the Olive Hotel to its present location it was a real news bonanza. The day the jacks were put under—big news story! When the timbers were set—another! When they got it up and on its way—another!*

I don't 'spose there were more than two or three automobiles in Orange twenty-one years ago. We've grown! It's been a steady growth, marked by fluctuations, but always a forward growth.

Our organizations have hastened our progress very materially. There would be times for long periods when the town would have no civic organizations—no Chamber of Commerce, no Merchants and Manufacturers—and those would invariably be times when business would slow up and growth lapse…It isn't the spasmodic effort with a town—with anything—that gets ahead. It's the continued pull—long, strong and steady.

Clubs and Organizations

Much of the civic life in early Orange was carried along by various clubs and organizations. In the nineteenth century, it was the fraternal organizations that led the way, but by the 1920s, service clubs and business groups had become more popular. Some groups were part of national organizations, while others were purely local affairs.

One of the first fraternal groups in town was the Independent Order of Odd Fellows, founded in 1874 (they were "odd" in the sense that they were not bound together by religion or politics but, rather, by a common purpose to help one another). The local lodge soon folded but was revived in 1898 and remained active for more than half a century.

Even earlier was the Patrons of Husbandry, better known as the Grange, organized in 1873. Unlike most groups of the time, the Grange welcomed both men and women and especially appealed to farmers and their wives. As in many pioneer communities, the Orange Grange soon founded its own cooperative store. All of the members were stockholders and could buy goods at 10 percent over cost. The Grange Store operated from 1875 to 1877 before closing up and selling off its remaining stock.

The only nineteenth-century organization still active in Orange is the Masons. The Orange Grove Lodge #293, Free & Accepted Masons, was first chartered in 1888, just as the city incorporated. The Masons and the Odd Fellows both had affiliated women's organizations—the Eastern Star for the Masons and the Rebekahs for the Odd Fellows.

The most prominent women's group in early Orange was the local chapter of the Woman's Christian Temperance Union (WCTU), founded in 1883. Besides its continuing efforts to restrict the sale of alcoholic beverages, the WCTU also took the lead in other social concerns and civic projects. That

A Growing Community

role was later largely taken over by the Woman's Club of Orange, which was founded in 1915. In 1924, the club built its own clubhouse on South Center Street, across from city hall, where it still meets to this day.

One of the strongest philanthropic groups in Orange is the Assistance League, organized in 1941 with thirty-two prominent local women as charter members. Its many projects (including the start of the Orange Youth Employment Service in 1961 and a downtown dental clinic) have been funded in part by its thrift store, which first opened in 1948 and in 1961 moved to its current location on the Plaza Square.

After World War I, two veterans' groups appeared in Orange—the American Legion (founded in 1919) and the Veterans of Foreign Wars (VFW). The American Legion dedicated its present home on South Lemon Street in June 1928.

There were several attempts to form a local chamber of commerce here over the years, beginning as early as 1888. The Orange Merchants & Manufacturers Association (M&M)—organized about 1905—was the most successful. The M&M finally disbanded in 1927 but was immediately reborn as the Orange Mercantile Association, the first of many downtown merchant groups that have continued off and on to this day. The Orange Community Chamber of Commerce was founded in 1921 and soon established itself as a leader in civic affairs. It remains active to this day. For younger men interested in community service, there were the Junior Chamber of Commerce—the longtime sponsors of the Orange May Festival—and the 20-30 Club, founded in 1932.

Service clubs first began to appear in Orange in the years following World War I. The first club chartered here was the Orange Rotary Club, organized in October 1921. Next came the Lions Club, which was chartered in May 1923. That same year, the Orange Elks Lodge was chartered—the last of the old fraternal organizations to come to Orange.

For Orange's younger set, the first important youth organization was the Young Men's Christian Association (YMCA), first organized here in 1907, the same year the Orange County YMCA was founded. After a lapse, the YMCA was revived here in 1922 and in 1925 joined the county group in founding Camp Osceola at Barton Flats in the San Bernardino Mountains.

The Young Women's Christian Association (YWCA) began at Orange Union High School in 1921. In 1949, the two Y groups combined their resources to build their own building at 146 North Grand, with meeting rooms, offices and a gymnasium. Later, the YWCA took over the entire facility, and in 1973, the YMCA built a new youth center near Yorba Park.

Today, the old Y building downtown is owned by the First Presbyterian Church.

The Boy Scouts came to Orange in 1912, just two years after the Boy Scouts of America was founded. The first troop in Orange was the second troop in Orange County. In 1920, Scout leaders from Orange helped to found the Orange County Council of the Boy Scouts of America. Their first summer camp was held along Santiago Creek in the summer of 1921, about where Santiago Oaks Regional Park is today. In 1922, the council opened Camp RoKiLi not far from Camp Osceola in the San Bernardino Mountains. It was named for the three service clubs that did the most to help build the camp—the Rotary, Kiwanis and Lions. Camp RoKiLi served until 1964, when it was replaced by the council's current summer camp at Lost Valley in northeastern San Diego County.

In 1933, the Boy Scouts established a weekend camp on Irvine Company property in Limestone Canyon, above Irvine Lake. Two years later, they moved to the old County Health Camp (now part of Irvine Park). In 1952, the Irvine Company leased the Scouts a weekend camp in the lower end of Peters Canyon, dubbed Camp Myford in honor of Irvine Company president Myford Irvine. It closed in 1986. In 2009, the Orange County Council opened its new Irvine Ranch Outdoor Education Center across the creek from Irvine Park.

The Girl Scouts came along a little later. The first troop in Orange was organized in 1924, and in 1927, a local council was formed. It merged with the Santiago Council in 1959 and today is part of the Orange County Council of the Girl Scouts of America. The Elks have always been strong supporters of both the Boy and Girl Scouts, and in 1939, they built the girls a meeting hall at 344 Toluca Avenue. In 1947, they built the Boy Scouts a cabin on the edge of Hart Park, but it burned to the ground in 1972.

There were a number of other youth groups active in early Orange. The Masons sponsored the Order of DeMolay (organized here in 1922), Job's Daughters and the Order of Rainbow for Girls. The Ys had their Indian Guides and Indian Princesses. Then there were all the church youth groups—the Walther League for the Lutherans, the Epworth League for the Methodists and so many others.

The Great Depression

The Great Depression was slow to arrive in Orange. The stock market crash of October 1929 had little immediate effect here. In fact, 1929 marked one

A Growing Community

of the biggest citrus crops in our history, and while the 1930 crop was smaller, prices still remained high. It was only when the citrus market collapsed that Orange's economy really began to suffer.

Unemployment in Orange County ran well below the national average (which sometimes rose as high as 25 percent in the 1930s), but every family still felt the pinch. Homeless men lived in a number of "hobo camps" around Orange, mostly scattered along the Santiago Creek.

More than a dozen Orange County banks failed during the early years of the Depression, including the First National Bank of Olive. The First National Bank of Orange survived the crash and did everything it could to help the community stay afloat. And when First National had done all it legally could, bank president N.T. Edwards would sometimes make personal loans out of his own pocket to help needy families.

With no federal relief programs to turn to, Orange had to look after itself. Churches, civic organizations and private individuals all did their part. Many of the local relief efforts were coordinated through the Orange Community Welfare Board, which had been organized in the late 1920s. The Welfare Board collected and distributed donations of food and clothing and operated several

The original Plaza fountain found a new home in 1940 next to the Plunge, Orange's municipal swimming pool in Hart Park, which was built by the WPA in 1936. For children not yet old enough to swim, the old fountain made a handy wading pool. *Courtesy the Orange City Clerk's Office.*

cooperative programs where the needy could trade their labor for purchases from the welfare store. Women might repair donated clothing or can fruits and vegetables; men could help harvest donated crops or work in the warehouse.

With the coming of Franklin Roosevelt's New Deal, a number of public works projects were launched in and around Orange. Much of the construction work on the Orange City Park (today's Hart Park) was paid for with federal dollars. Orange also got a new post office downtown, Orange Union High School got a new grandstand (now gone), Olive Elementary School got an auditorium and a variety of street, sewer and storm drain projects were completed.

The New Deal was originally so popular that Orange County saw its first Democratic majority ever—though not in Orange, which remained firmly in the Republican column. Franklin Roosevelt even carried Orange County in the 1932 and 1936 presidential elections, but as he expanded his New Deal programs further and further, his local support faded, and Orange County soon swung back to the Republican ticket.

The 1930s were also marked by several natural disasters in Southern California. The Long Beach earthquake in March 1933 caused extensive

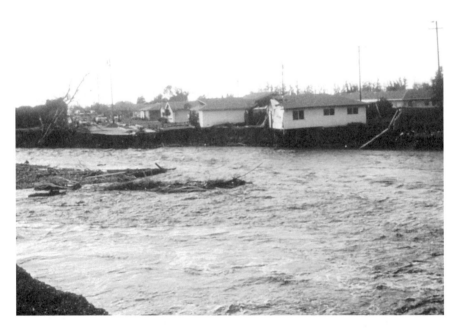

Flooding on the Santiago Creek in 1969 swept away several homes in Orange and caused several fatalities in Orange County. These ill-fated homes are at the east end of Walnut Street. *Courtesy the Orange Public Library and History Center.*

damage and several deaths in Orange County, though Orange was spared the worst of the destruction. In January 1937, several nights of freezing temperatures (down into the mid-twenties) caused major damage to the local citrus crop. Returns were down 20 percent that year in an already limited market.

The year 1938 is still remembered as the year of the great flood. The 1938 Flood was the deadliest in Orange County's history. Heavy rains began falling on February 27, and within a few days, the Santa Ana River was a roaring monster. On March 3, the river broke out of its banks and poured through downtown Anaheim on its way to Buena Park. There was heavy damage and a number of fatalities in the communities along the river, especially in the Mexican American neighborhoods in Atwood and La Jolla, on the north side of the Santa Ana Canyon. There were no fatalities in Orange, but most of the local bridges were washed out, and many orchards and fields were buried under thick layers of mud. Finally, in 1939, a rare hurricane swept the Orange County coast, with howling winds and raging temperatures.

The 1930s were also marked by labor unrest and several major agricultural strikes. The largest began in June 1936, when nearly three thousand Orange County orange pickers (mostly Mexican Americans) walked out during the height of the Valencia season. They demanded union recognition, a pay raise, more job security (field foremen could pretty much fire workers at will) and an end to the practice of withholding part of their salary until the end of the season. The growers refused to negotiate. More than one hundred of the strike leaders were arrested, and violence began to break out in the groves as other workers were brought in to do the picking.

The strike dragged on for six weeks. The growers never did negotiate but did agree to a few of the pickers' demands, including a slightly higher wage and the end of salary withholding. The Citrus Strike of 1936 changed the relationship between growers and their Mexican workers forever.

There were a few bright spots here and there in the 1930s, though. In 1933, the annual May Festival parade was launched to celebrate the start of the Valencia harvest. It later grew to include a carnival. Sometimes other events were tied in with the May Festival. The 1935 edition featured the dedication of Orange Union High School's new grandstand. The year 1936 saw the launch of Orange's famed all-girl softball team, the Orange Lionettes. Originally sponsored by the Orange Lions Club (as the name would suggest), the team went on to win several world championships during its forty-year career. In 1937, it was the formal dedication of the

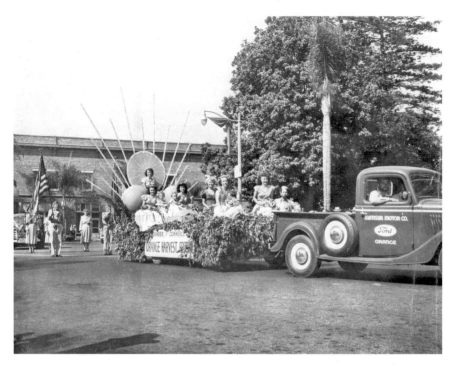

The Orange May Festival parade (sometimes known as the Harvest Festival, as in this 1940s photograph) always featured Miss Orange and her court. *Courtesy the Geivet Collection, Old Orange County Courthouse Museum.*

Orange Plunge. The year 1938 was the biggest of all, with both the fiftieth anniversary celebration of Orange's incorporation and the dedication of the new Santa Fe Depot.

WORLD WAR II

Sadly, it was World War II that really brought an end to the economic Depression of the 1930s. Memories of World War I were still strong, and many Americans believed the United States should stay out of "that European war," which broke out in 1939. But as the war spread, people could see what was coming, and all hesitation was swept away on December 7, 1941, when the Japanese attacked Pearl Harbor. America was going to war.

For Orange, the most memorable event of the early weeks of the war was the arrival of the Thirtieth Field Artillery Battalion sometime around

A Growing Community

the first week of January 1942 (the date is a little vague because the *Orange Daily News* was cautious about printing too much information about the troops, which were usually simply referred to as "the army unit stationed in Orange"). The soldiers were housed all over town, in church basements, public halls and spare bedrooms. The Thirtieth was stationed in Orange for several months while the men went off company by company for training in the desert to prepare for service in North Africa—except, when the time came to go, they were sent to Alaska instead!

A number of major military installations were built in Orange County during World War II, including the El Toro Marine Corps Air Station and the Lighter-than-Air base south of Tustin, with its massive wooden blimp hangars. Orange never had anything so grand, but in November 1942, the army took over Irvine Park as a training base. In 1943, they moved their operations just west of the park into the old Boy Scout camp, which they named Camp Rathke, in honor of Lieutenant George Rathke of Orange, a young soldier who had lost his life in a training exercise on San Clemente Island a few months before. A couple miles south, on the shores of Lower Peters Canyon Reservoir, the army laid out Camp Commander. These were training camps, and war games and artillery practice were held in the local hills.

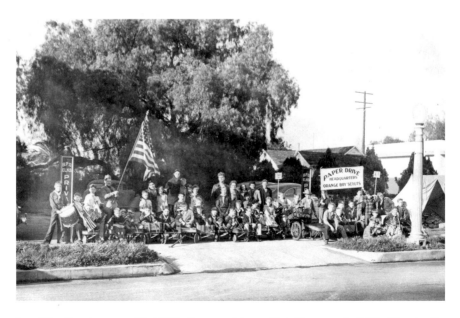

Local Boy Scouts stage a World War II paper drive on East Chapman in 1945. All sorts of material were salvaged for the war effort. *Author's collection.*

Hundreds of young men and women from Orange enlisted or were drafted into the armed forces. Hundreds more went to work in factories in Long Beach or Los Angeles, churning out planes, tanks, vehicles and other war materiel. In 1943, four hundred Orange-area residents worked at Douglas Aircraft's Long Beach plant alone, while others found jobs closer to home at "feeder" shops, which assembled smaller components for shipment to the larger plants. This meant less driving in an era of gas and tire rationing. By 1944, about one thousand local residents were employed in defense work. Even high school students were encouraged to take on four-hour factory shifts in the afternoon and evening or to work in the fields during harvest time.

Other agricultural workers were brought up from Mexico through the national Bracero program. A workers' camp was established at Cypress Street and Walnut Avenue about 1944. When that proved insufficient, Jamaican workers were tried and then, in 1945, German POWs housed at a camp in Garden Grove.

Everyone was expected to do their part. There were scrap drives for everything imaginable, starting with most anything made of metal, from pots and pans to coat hangers, as well as paper, rags, kitchen grease and even old deer hides to be made into gloves. And to help fund the war effort, hundreds of thousands of dollars' worth of war bonds and saving stamps were sold in Orange.

More than fifty local servicemen lost their lives in World War II. Many others were wounded in action or were captured as prisoners of war. Some never recovered from the trauma; their lives would never be the same.

Orange would never be the same, either.

Chapter 5
TRACT HOMES AND FREEWAYS

The boom started after World War II when so many young boys in the service came through here on their way to the Pacific theater of war. They were based at the Santa Ana Army Air Base and at El Toro. After staying here two to three months they got to like the state of California, and they wanted to come back. So as soon as the war was over, they all decided to come back here to live. Not only that, but by that time they were older, they wanted to get married and have their families. Then they brought their father and mother and Aunt Minnie and the whole group of them... Then we had a baby boom on top of that. This started what you might call a whole new civilization coming at us for awhile. I can remember one year we had 14,000 people all move in on us.
—George Weimer, Orange's first city manager, oral history, 1979

Orange in 1950 was little changed from Orange in 1930. In twenty years, the population had grown from eight thousand to ten thousand, but you hardly would have known it. Downtown looked much the same, and even many of the same old-time businesses could still be found around the Plaza.

But elsewhere in Southern California, things were changing. Young veterans and their baby boomer families began flooding into the region, attracted by the mild climate, the suburban lifestyle and the prospect of good jobs. Much of the initial growth in the late 1940s was centered in Los Angeles and then spread outward from there. Tract housing didn't reach Orange until 1950, with the opening of the 98-home Bitterbush Tract on

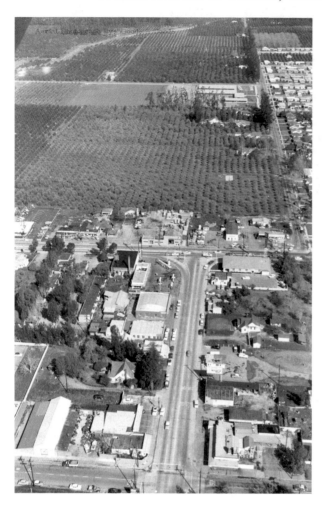

Main Street dead-ended at Chapman Avenue in 1958. This was the state highway before the freeways were built, and since the little business community that grew up around the curve was midway between Orange and Santa Ana, it was dubbed Orana. *Courtesy the Orange Public Library and History Center.*

the north side of West Chapman, just east of the Santa Ana River. In all, 276 new homes were built in Orange that year.

New home construction continued here year by year, with things really picking up in 1955–56. Much of the construction then was on the west side of town and a little more to the north. Initially, almost all of the new construction was single-family homes, but to the west, many of the tract homes were soon joined by apartments, which greatly increased the density of the area. By the 1970s, one-third of the city's population lived west of Glassell and south of Chapman.

As much of the area around Orange had been small citrus groves of ten to twenty acres, the new tracts appeared piece by piece, as some growers

Tract Homes and Freeways

sold out early and others held on to their groves for several more years. By the 1960s, anywhere you looked around Orange there were homes in every stage of construction. Most were built in an assembly line fashion—all the slabs poured at once, with the plumbing stubbed in and then the walls framed and pre-built roof trusses lifted into place. Even some of the chimneys came prefabricated, trucked in in one piece. Some tracts were built by local developers, but most were built by outsiders.

In the rush to build quickly and cheaply, some builders still tried to create more distinctive homes. Developer Joseph Eichler built his first Southern California tract in Orange in 1960. He eventually built three tracts here—Fairhaven, along the southern edge of Orange near Fairhaven and Esplanade; Fairmeadow at Taft and Cambridge; and Fairhills above Linda Vista Elementary, in the foothills south of Santiago Canyon Road. Known for their low lines, flat roofs and indoor-outdoor feel, the Eichler "mid-century modern" look has become increasingly popular in recent years.

Unlike some of our neighbors, Orange was in no hurry to be a big city, but by the early 1950s, the city was annexing more and more territory, pushing its boundaries north and west. Between 1950 and 1960, the city grew from 3.8 square miles to 8.25 square miles. During the next three years, the city annexed another 4,100 acres, much of it to the north and east. The city

Looking along Katella Avenue at Cambridge Street, circa 1960—two lanes, no sidewalks and eucalyptus wind breaks all around—a far cry from today's busy commercial street. *Courtesy the Orange County Archives.*

grew all the way west to touch Garden Grove and soon surrounded Olive, El Modena and Villa Park.

A special census in June 1953 found 12,305 people living in Orange. By October 1955, the population had topped 16,680. ("They would take it on a Friday," city manager George Weimer joked. "Probably another 200 moved in over the weekend.") The 1960 federal census gave Orange a population of 26,444—up 226 percent in a decade. In the next three years, the population

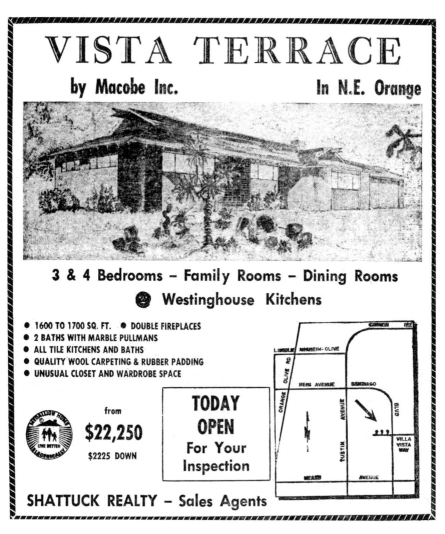

Vista Terrace homes started at $22,250 in 1961. Located on Villa Vista Way, just west of Santiago Boulevard, the homes showed a touch of the Polynesian styling then popular in Orange County. *From* Orange Daily News, *July 14, 1961.*

more than doubled, with the city growing by about 1,000 residents per month in the early 1960s.

It was not until the late 1960s that Orange's expansion finally slowed, but it took the energy crisis and the inflation of the 1970s to finally bring an end to Southern California's postwar housing boom. In 1962, Orange city planners had predicted a population of 100,000 here by 1970; in fact, that total wasn't reached until the end of 1985.

Many of those new residents found jobs outside of Orange, often in Southern California's booming aerospace industry. By 1963, for example, more than one thousand local residents worked at the Autonetics plant in Anaheim. Like much of Orange County, Orange was becoming a bedroom community.

Industrial development in Orange ran mostly to small manufacturing plants and commercial services. The city was determined to keep its industrial areas from spilling over into residential and commercial areas. Zoning became the tool to keep different types of development from infringing on one another. It was a process the city had to learn as it went along. In the early 1960s, some 1,200 acres (mostly in the northwest part of town) were zoned for industry, though much of it was not developed until the 1970s. By

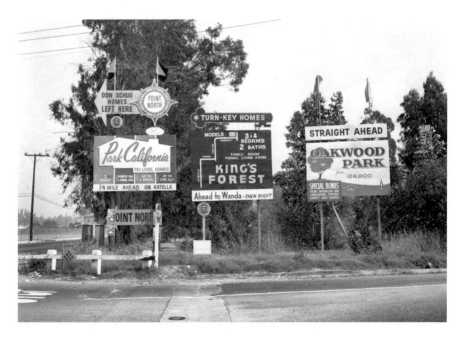

Subdivision signs clutter the corner of Handy and Katella, circa 1965. The orange grove behind them was not replaced by tract homes until the 1970s. *Courtesy the Orange County Archives.*

1970, some two hundred industrial firms in Orange were employing more than five thousand people.

Retail sales and the service sector also saw a major jump in employment during the postwar boom. Supermarkets, department stores, restaurants and the healthcare industry created jobs for thousands of new residents. The mix of retail and industrial development was vital to the health of the community. It provided both a job base and a tax base for Orange.

But not everyone welcomed Orange's continuing growth. Many residents of Villa Park saw subdivisions as a threat to their "rural atmosphere" of custom homes and citrus groves. Rather than annex to the City of Orange, in 1961 the Villa Park Property Owners Association began the push to form its own city in order to preserve its low-density zoning.

After a lively debate on both sides, local voters went to the polls on January 2, 1962, and voted 257 to 134 in favor of incorporation (an 84 percent voter turnout). The tiny new city only had a population of about 1,300. Except for the Villa Park Orchards packinghouse, the entire area was residential or agricultural. Villa Park contracted with the county for most of its municipal services and was so intent on retaining its rural residential flavor that it did not even allow any commercial development until 1969, when the city's one and only shopping center opened.

The City of Orange then guaranteed that Villa Park would remain one of Orange County's smallest cities. Within three years, it had annexed itself all the way around Villa Park, locking it in forever.

City Services

To keep up with its growing population, the City of Orange had to expand both its staff and its facilities. By 1955, plans were in the works for a new civic center. After considering a location near Glassell Street and Rose Avenue, the city began buying up property adjoining the old city hall on East Chapman. In 1963, a new $1.5 million, fifty-four-thousand-square foot civic center was completed. The current city council chambers sit on about the location of the old city hall.

Almost all of the city departments had their offices in the new civic center in 1963. Over the years, though, many have expanded to other locations. In 1990, the police department moved into a new $11 million facility at the old city corporation yard at the northeast corner of Batavia Street and Struck Avenue, opening up a great deal of space in the civic center. The fire

Tract Homes and Freeways

The Orange City Water Department workshops and storage tank on—appropriately enough—Water Street in 1938. The tower-top tank helped to regulate water pressure in town. *Courtesy the Orange Public Library and History Center.*

department and water department also have their own headquarters, and other city offices are housed in remodeled commercial buildings near the civic center.

Besides their new headquarters, the Orange Fire Department also established a string of fire stations throughout the city. Station #2, the first outlying station, opened at Collins Avenue and Wanda Road in 1959. The most recent (#8) opened at Cannon Street and Carver Lane, in the northeast corner of town, in 1999.

Orange's old Carnegie library building was jammed for space by the 1950s, but voters turned down three successive bond acts to replace it before finally approving $450,000 in library construction bonds in 1959. The old library building closed later that year, and the books were moved to a temporary location downtown until a new building was completed on the old site in 1961. Branch libraries later followed on Taft Avenue and in El Modena.

Orange got a new public library in 1961. The old building is now part of the expanded Orange Public Library and History Center, which opened in 2007 after two years of construction. *Courtesy the Geivet Collection, Old Orange County Courthouse Museum.*

Parking had become a problem even before the big boom hit Orange, so in 1947, the city installed parking meters on all the major streets downtown. The city council, led by Mayor George Weimer, knew this was an unpopular move but promised that revenue from the new meters would go toward the purchase of free downtown off-street parking lots, and once the parking lots were in place, the meters would go—and that's just what they did! The parking meters have been gone for more than half a century now, but the free city parking lots remain.

Orange's growth to the west eventually took in the old Orange County Hospital, which had opened in 1914. The hospital was later sold to UC–Irvine, which took over operations in 1976. In 2009, it completed a major expansion with the opening of its new University Hospital.

In the 1950s and '60s, the county added several more facilities near the hospital. Juvenile hall, the Theo Lacy Jail and the county animal shelter had all been built by 1960, and a headquarters for the county library and new offices for the Probation Department soon followed.

Where irrigation water was key to the birth of Orange, a dependable domestic water supply was now necessary for the city's postwar growth. In 1870, Alfred Chapman had gone just a few miles north to the Santa Ana River to find water; now it would come all the way from the Colorado River.

The Metropolitan Water District (MWD) of Southern California had been created in 1928 to build the Colorado River Aqueduct and provide water to its members. As Southern California began to boom in the 1940s, more and more communities wanted in on the deal. MWD set a number of requirements, most notably that any new members would have to pay their back taxes as if they'd been part of the district from the beginning—though they did at least allow them to pay them off over time.

In 1949, Orange, Huntington Beach, Placentia, La Habra and Seal Beach formed a joint committee to push for the formation of a municipal water district that could then apply for membership in the Metropolitan Water District. The original plan took in just the five cities as they existed at the time. MWD turned the proposal down flat. They wanted the new district to take in virtually all of Orange County that was not yet part of MWD. New boundaries were drawn that took in much of northern and central Orange County, and an election was held in January 1951 to form the Municipal Water District of Orange County. There was some concern among ranchers that imported water would be too expensive, but there was no organized opposition, and the measure passed easily, 10,962 to 879. The Metropolitan Water District of Orange County was then allowed to join the MWD. Glenn Allen, a former mayor of Orange, was elected the first president of the MWDOC and served the district for the next thirty-five years.

The city of Orange initially tapped into MWD's Orange County feeder line near the County Hospital, and the first Colorado River water reached here in 1954. Today, our water supply is a mix of local groundwater and imported water delivered through several major MWD feeder lines.

A View from City Hall

George Weimer had a front-row seat for the hectic growth of the 1950s and '60s. After serving as mayor in the 1940s, he became Orange's first city manager in 1953, serving until 1968. In that new role, he was determined to do what was best for the community, even if it meant stepping on toes. A sign on his office wall declared: "One Rule for Failure—Try to Please

Everybody." In these excerpts from a 1979 oral history, he reflected on the rush of growth in the postwar years:

> *Back in the 1940s we had to take a strong look at how we were going to prepare for the future. People were saying, "When this war is over, these servicemen are going to come back here to live. We had better get ready for them." We wanted to get things going for the benefit of everybody in town. We had a problem looking ahead to see how we were going to take care of water, sewers, and everything that went with it. Where I first came here in 1925, you just had a little over 7,000 people in Orange. In 1950, we only had 10,053, 25 years later. Then look what started happening, when it started to go, look where she went...*
>
> *At one time, I remember, for two or three years we had about 2,000 building lots either being built on and approved or being finished. You can imagine what happened when you put three or four people in each one of those houses...*
>
> *We were really fortunate because we had some of the best builders in Southern California building in Orange. They built good homes and had a good reputation. We had a few come in who tried to cut corners here and there, but they cut into one tract and that was about as far as they got because we were pretty tough. I will say that. The City of Orange was not easy, particularly when we ran into somebody who decided to cut a few corners and leave us, and the people who were buying these things, the package. We were quite severe on those people and watched them pretty closely, and they stayed away from us...*
>
> *By the 1960s, when things were booming, we had a setup down there in the city hall where you walk in, the whole building was designed so that when you walked in there, you could get everything you wanted at one counter. There's the planning and zoning, the building inspectors, and the street superintendent. There's sewer and the whole bit, all right there. You don't have to run from pillar to post to find out where you're going, or run to two or three buildings or up and down four or five floors. These fellows would could come in and get the whole thing in one package. You can imagine how easy it was.*
>
> *They would bring a tentative map first and they had to get their engineering done for what they were going to build. Of course, the tentative map and the engineering had to coincide with the zoning for the property they were going to build on. Once they came through with the subdivision all set up according to our zone and addendum sheets and everything else we had*

Tract Homes and Freeways

to go with it, then it would go to planning commission and be tentatively approved if it was right. If it wasn't right, they wouldn't accept it.

If the planning commission passed it, then two weeks later it went to the council. If the council passed the tentative map then the guy was assured. He could go out and get his financing and go to town, because he knew when it came to the final map, as long as the plans didn't change from the tentative map, it would be approved.

We used to take tracts through here two and three a week. I would say if they were in our office thirty days there was something wrong with them.

If nothing else ever happened to me, I think the two or three things I would like to look back at and be really proud were, number one, getting the Municipal Water District of Orange County through, and number two, getting the countywide sanitation district through. To me these were big things: to set up a countywide sewer system and without it this county could never have grown. Nor could we have grown without Metropolitan water. If you don't have those two things you have nothing. You have to have water and you have to have a way to take it away when you are through with it...

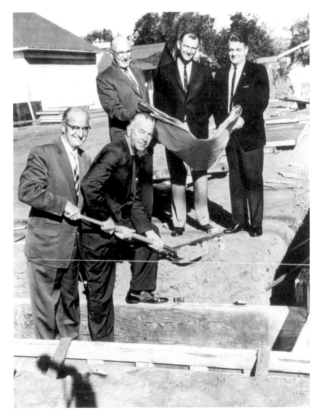

Breaking ground for Bank of America's new downtown branch on East Chapman, 1961. On the shovel are City Manager George Weimer and branch manager Otto Zipwald. Behind (left to right) are Councilman Rex Parks, chamber of commerce president Bob Hoyt and Mayor Gene White. The site is now part of the library parking lot.
Courtesy the Orange Public Library and History Center.

> *Now there are too many people in our city, I'll say that. This idea of being big for bigness sake, as far as I'm concerned, is for the birds. What I was trying to do, and I still think it was right, is to keep a compact, economically sound city through residential, commercial, and industrial balance.*

Expanding Education

Orange's schools felt the impact of the postwar population boom more than any other local institution. The 1940s and '50s were a time of many changes in the way our local schools were run.

Beginning in the 1920s, Orange was one of several Orange County school districts that segregated most Mexican American children. In 1931, a separate Cypress Street School opened, north of Walnut Avenue, for immigrant children for Orange's growing barrio. But in 1944, Orange desegregated its schools. The Cypress Street School was closed, and all the children were sent to nearby Killefer Elementary. School superintendent Stewart White pushed for the change, arguing that "mixing of the children would further the Americanization program and promote friendly Latin-American relations."

El Modena (still a separate district at the time) also maintained separate schools—Lincoln for the Anglo children (and a few Hispanic students judged able to keep up with the curriculum) and Roosevelt, for Mexican Americans and apparently a few children of the Japanese American farmers leasing land from the Irvine Company in Peters Canyon.

In 1945, a group of Mexican American parents sued four Orange County school districts, seeking to force desegregation. El Modena was included in the case of *Mendez v. Westminster*. The school districts argued that immigrant children were only grouped together so they could be taught English and that "separate but equal" schools were legal. Most of the Mexican schools also ran on a different schedule, starting in August so students could take time off to work with their parents in the walnut harvest in September and October. But District Court judge Paul McCormick disagreed. Besides violating the students' right to equal protection under the law, the Mexican schools were far from equal in their buildings or equipment.

In September 1946, while the case was still out on appeal, El Modena desegregated its two schools. In April 1947, the Ninth Circuit Court of Appeals upheld Judge McCormick's ruling, leading to the desegregation of all California schools, seven years before the U.S. Supreme Court did the same for the rest of the United States in *Brown v. Board of Education*.

But the transition was not without conflict. Soon after desegregation, some of the Anglo residents in the El Modena School District began pushing to leave the district for neighboring schools. It was the breakup of the El Modena School District that prompted the first vote to combine the five local elementary school districts (Orange, El Modena, Olive, Villa Park and Silverado) that shared Orange Union High School into one single "unified" school district. The proposal went before the voters in 1948 and went down solidly to defeat.

And there were more troubles. Following the 1933 Long Beach earthquake, the State of California tightened construction requirements for public schools (many of which had collapsed in the quake), and by 1948, much of the old Orange Union High School campus had been declared unsafe. Bringing the buildings up to code would be expensive, so in November 1948, the trustees placed a $1.25 million construction bond on the ballot. It failed in every precinct.

Six days later, the entire high school board of trustees resigned, hoping to get the community's attention that this was their problem, not just the board's. A new school board was appointed, and the debate continued. Rather than rebuild, the new trustees decided to find a new site for the high school. A second $1.25 million bond act was approved in 1950, and construction began in March 1952 at the corner of Walnut Avenue and Shaffer Street. On May 15, 1953, the student body walked en masse to their new home.

The unification question was also revived in 1952, and after an aggressive campaign, the measure was approved in September 1952. The Orange Unified School District officially came into existence on July 1, 1953, with former OUHS principal Harold Kibby as its first superintendent.

As Orange grew, the older schools began to bulge at the seams. Center Street School was almost fifty years old; Maple Avenue was a good thirty. Maple Avenue was replaced in 1951 by Cambridge Elementary. A year later, Palmyra Elementary opened, and Center Street closed. For children in the new tracts on the west side of town, Sycamore Elementary opened in 1956. In 1959, three new elementary schools were added—La Veta, California and Handy Elementary, out on the east side of town.

But even that was not enough. Orange's student population doubled in the late 1950s, passing eleven thousand in 1961 and forcing many local schools into double session. Simply put, the developers could build houses faster and easier than the district could build schools. Bond issues had to be approved by local voters and plans reviewed in Sacramento, while the new houses just sprang up like weeds. It was not until the mid-1960s that Orange Unified finally got caught up. By 1975, there were thirty thousand students enrolled in the district.

Orange High School faced the same sort of overcrowding until two new high schools were added in the 1960s—Villa Park in 1964 and El Modena in 1966. Canyon High School followed in 1974.

When Orange High left its original campus behind in 1953, no one was quite sure what to do with the old buildings. When the old Center Street School was closed around the same time, it was torn down and replaced by apartments. But in 1954, Chapman College, a small Christian liberal arts school, bought the old buildings and moved down from Los Angeles. It had about four hundred students at the time.

Chapman had been thinking about moving to Orange County since the 1930s and had looked seriously at a location in Orange in 1948. The school traces its ancestry back to Hesperian College in Northern California, which was founded in 1860 by the Disciples of Christ. Chapman opened in Los Angeles in 1920 and was known as California Christian College before it was renamed Chapman College in 1934 in honor of its biggest benefactor, Fullerton citrus millionaire C.C. Chapman (no relation to Orange founder A.B. Chapman). In 1991, it was renamed Chapman University.

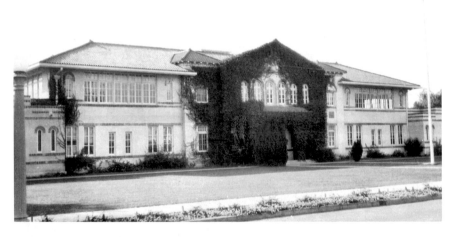

The Orange Intermediate School was built in 1914, across North Glassell from Orange Union High School. It served seventh- and eighth-grade students. Later it became the offices of the Orange Unified School District. The façade—covered in ivy in this 1930s photo—has been preserved as part of Chapman University's law school building. *Courtesy the Orange County Archives.*

Tract Homes and Freeways

As a private college, Chapman was not bound by the same strict building requirements as the public schools and could move right into the old high school buildings. In 1996, Chapman acquired the old Orange Unified School District offices across the street and built a law school on the site. The university now owns many other buildings on the west side of downtown, including the old Santiago Orange Growers packinghouse and the historic Cypress Street School. A portion of the old Anaconda plant has become the site of its film school, and plans are in the works to restore some of the other old industrial buildings.

BUSINESS ON THE MOVE

As Orange expanded outward, new business districts began to spring up, and downtown's importance as a commercial center began to fade. In 1956, Orange Square, the first major shopping center along Tustin Avenue, opened at the northeast corner of Tustin and Chapman Avenue. Within a few years, more shopping centers (usually anchored by a supermarket) opened at other major cross streets such as Collins and Walnut Avenues. Banks and gas stations were soon vying for other busy corners. Restaurants appeared as well, including the first Marie Callender's, which opened in 1963 and is still in business at its original location. (Tustin is actually Tustin Street as it passes through Orange and Tustin Avenue everywhere else, but most people, many businesses, the freeway signs and even a few maps call it Tustin Avenue all the way through.)

Orange's commercial growth continued to spread as the city grew. In 1962, our first high-rise—the twelve-story Union Bank tower—opened at the southwest corner of Main Street and La Veta Avenue. The first section of the Town & Country office and commercial center, with its carefully landscaped Spanish-style buildings, opened nearby that same year. In 1968, the TusKatella Center opened at the northwest corner of Tustin and Katella Avenue, featuring a Vons, a Builders Emporium and a Sav-On drugstore. At Tustin and Lincoln Avenue, The Brickyard opened in 1978 on the site of the old Mission Clay Products.

As commercial growth expanded into other parts of town, downtown Orange began to falter. The chain stores pulled out one by one—the Cornet Store and the JCPenney were the last to go, in 1973 and 1974, respectively. Downtown was turning into a ghost town. That's when the antique dealers discovered downtown Orange.

The first few antique stores appeared downtown in the 1960s, but it was not until the mid-1970s that the real boom in antique dealers began. By the

A Brief History of Orange, California

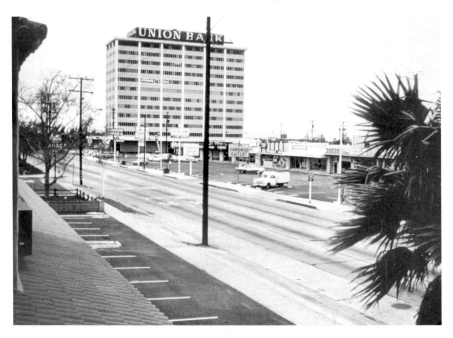

The Union Bank tower at Main and La Veta, circa 1965. This was Orange's first skyscraper, built in 1962. *Courtesy the Orange County Archives.*

end of the decade, there were about thirty different shops downtown, and the Old Orange Antique Dealers Association began sponsoring an annual Antique Faire each February.

The 1980s saw the rise of the "antique malls," with any number of smaller dealers sharing space in one store. The antique malls have come to dominate the market, and today there are only a handful of individual antique dealers with their own shops downtown.

More and more restaurants, sidewalk cafés and coffee shops opened downtown beginning in the 1990s, along with art galleries, specialty shops and professional offices, such as architects and accountants. All of this new growth has put the squeeze on the antique dealers but has also greatly expanded the foot traffic in the area and even created a little nightlife downtown.

The area around the old Santa Fe depot (which closed in 1970) began to revive with the arrival of Metrolink commuter rail service at the end of 1993. The depot has been converted to a restaurant, Depot Park has been spruced up, free parking and a pedestrian underpass have been provided for commuters and businesses and residential lofts have moved into the area.

Tract Homes and Freeways

But just as downtown Orange suffered as businesses moved out to Tustin Avenue in the 1950s and '60s, Tustin Avenue began to feel the pinch in the 1970s as the malls arrived. In the early 1970s, two major retail centers opened on opposite sides of Orange—the Mall of Orange (now known as the Village at Orange) and The City Shopping Center (which became the Block at Orange). The Sears store at the south end of the Mall of Orange opened in 1967. The mall itself opened on August 16, 1971 (a date, it was said, selected by an astrologer to help ensure success). But the mall was never a huge success, and many tenants, large and small, have come and gone over the years. In 1997, it was joined by a Walmart on its northern end. After a $57 million renovation and a name change, the Village at Orange reopened in 2003.

The Block at Orange was a long time in coming. It was first proposed in 1959 as International Marketland, combining retail stores, offices, restaurants, entertainment venues and a hotel. The original developers were bankrupt by 1961. The new owners changed the name to the Four City Center to highlight its location between Orange, Garden Grove, Anaheim and Santa Ana. This

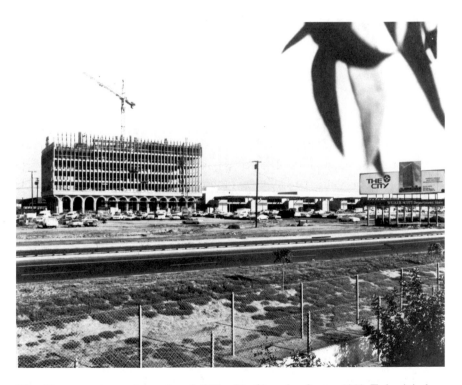

The office tower rises at the south end of The City Shopping Center, 1969. Today, it is the only major building still standing from the original complex. *Courtesy the Orange Public Library and History Center.*

was later shortened to simply The City. The first retail stores opened here in 1970, and the mall was anchored by a JCPenney and a Treasury store.

The City fell on hard times in the 1980s, particularly after the opening of the MainPlace shopping center on North Main in Santa Ana. Major retailers began to pull out in the 1990s, and in 1995, the entire shopping center was closed. Most of the buildings were torn down, and a new mall was built, dubbed the Block at Orange. It opened in 1998 with a mix of stores hoping to attract a younger crowd.

The City mirrored the evolution of local shopping malls over the years. Originally built as an open-air mall, it was later enclosed in an attempt to keep up with its climate-controlled competitors and finally rebuilt as an open-air mall once again. Today it is facing yet another name change as the current owners attempt to rebrand the Block as more of an outlet mall.

Others have taken the mall idea and turned it toward entertainment and dining. The best example in Orange is the Stadium Promenade, which opened on the site of the old Stadium Drive-In on Katella in 1997.

In an effort to revive Tustin Avenue as a commercial corridor, in 1983 the city formed its first redevelopment district there and launched a multiyear façade improvement program. Other redevelopment districts were later formed for the area around the City and along West Chapman Avenue, where residential as well as commercial projects have been completed.

Freeways and Fee Ways

If the real estate boom of the 1880s was built on the railroads, the post–World War II boom in Southern California followed the freeways. They not only opened up new areas for development but also, for better or worse, helped to create our commuter culture, as they carry people to jobs, shopping and entertainment throughout the Southland.

The first freeway into Orange County was the Santa Ana Freeway (Interstate 5), which cuts through the western corner of Orange. The first local stretch opened in 1953, and by 1960, it was complete all the way across the county from Buena Park to San Clemente.

The Costa Mesa Freeway (originally known as the Newport Freeway or State Route 55) had more of a direct impact on Orange. The route was approved in 1954, and construction began early in 1961 from Chapman Avenue north to Santa Ana Canyon Road. Later that same year, a second contract was signed to build the stretch from Chapman

Tract Homes and Freeways

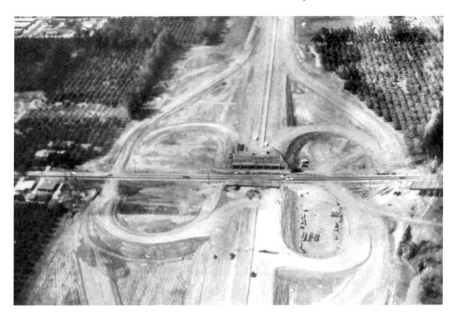

The Chapman Avenue interchange on the Costa Mesa (55) Freeway under construction, circa 1962. Notice the orange groves all around. *Courtesy the Orange City Clerk's Office.*

Avenue south to the I-5. By the end of 1962, the 55 ran all the way from the Santa Ana Canyon down to the I-5. Several later projects (the last in 1987) extended it all the way into downtown Costa Mesa, which gave the freeway its new name.

Construction on the Garden Grove Freeway (SR-22) began west of Main Street in 1963. It was completed east to the 55 in 1967. The Riverside Freeway (SR-91) on the northern edge of Orange was long in coming. Portions of it were under construction as early as the 1950s, but it was 1966 before work began on the stretch across the Santa Ana River from Olive, and it was not until 1971 that it was completed all the way out to the Santa Ana Canyon. In 1996, automated toll lanes were added through the canyon to try to ease the crunch of commuter traffic from the Inland Empire. Initially a private operation, the toll lanes were taken over by the Orange County Transportation Authority in 2002.

The first stretch of the Orange Freeway (SR-57) opened in 1969 from the 91 to Nutwood Avenue in Fullerton. The portion south of the 91 to Katella Avenue opened in 1974, and the freeway was completed in 1976. The 57 was originally planned to run all the way south to Pacific Coast Highway but was only built as far as the junction of the I-5 and 22 freeways, creating the harrowing triple interchange popularly known as the "Orange Crush."

As Orange pushed east into the foothills, so did the highways—only now, they were toll roads instead of freeways. The Eastern Transportation Corridor (SR-241), which runs south over the hills from the 91 freeway, opened in 1998 after five years of construction. At Santiago Canyon Road, State Route 261 splits off and heads south. It was extended down to meet the I-5 freeway in 1999. The 241 continues south to Oso Parkway, and plans are being developed to extend it to San Clemente at some future date.

Turning to the Past

As businesses abandoned old downtown Orange, various plans were floated to revive the area. The idea of transforming the Plaza area into a pedestrian mall was widely debated in the 1950s and '60s. Others proposed a "Super Plaza" with high-rise buildings all around.

The city did a little work to dress up the Plaza Square in 1969–70, but the beautification efforts soon stalled as the costs increased. The idea was reborn in 1979, now promoted as a historic preservation project. Under the leadership of Councilman Don Smith, one square mile of downtown was mapped out and dubbed "Old Towne." Renovations were carried out on Glassell Street (1983), Chapman Avenue (1985) and finally in the Plaza itself (2001). In 1983, a historic preservation element was added to the city's General Plan, and in 1988, the first set of design guidelines was issued for new construction and downtown remodels.

But even before the Old Towne project was born, local organizations had begun to take an interest in Orange's past. The first was the Orange Community Historical Society, founded in 1973. In 1979, the society established the Florence Flippen Smiley Memorial Archives, named in honor of one of the founders of the society. In 1989, the collection was transferred to the Orange Public Library, and it forms the basis for the library's local history collection.

In the mid-1970s, as blocks of beige tract homes filled other parts of Orange County, people began to turn back to Orange's historic homes, drawn by the charm of the historic architecture and hometown feel of the old neighborhoods around downtown. Renovating and restoring these homes has been a labor of love for hundreds of families over the years.

Realizing that their historic homes and neighborhoods needed extra protection, in 1982, Orange's first preservation group, Preservation Orange, was founded. It was short-lived, but in 1986, the Old Towne Preservation Association took up the challenge, and it has grown to be a major force in local affairs.

Tract Homes and Freeways

The Central Orange County YWCA sponsored the first historic home tours in Orange, held annually from 1978 to 1981. The Orange Community Historical Society offered biannual tours from 1984 to 1996 and now offers walking tours of downtown each summer. The Old Towne Preservation Association launched its own home tour in 1988, which continues biannually.

The Orange Community Historical Society began the push to gain historic recognition for downtown Orange in 1977, with an application to list the Plaza Square on the National Register of Historic Places. The plan was soon expanded to include much of the old downtown business district, which was placed on the National Register in 1982. In 1997, thanks to the efforts of the Old Towne Preservation Association, the surrounding historic neighborhoods—some 1,400 pre–World War II homes—were also listed on the National Register, making downtown Orange the largest residential historic district in the state of California.

Another interesting historical project was Pitcher Park, at Cambridge Street and Almond Avenue, which was donated to the city by Alice Pitcher in 1989 in memory of her late husband, Laurence Pitcher, and his parents,

The first Orange International Street Fair in 1973 attracted about fifty thousand people—a far cry from today's crowds. Though begun to honor Orange's centennial, the event missed the correct date by two years. *Photo by the author.*

who had owned the property since 1912. The old house was torn down, and the corner was converted into a historic park, with specimen trees, a honey house and a barn that serves as the Orange Fire Department Museum.

Orange also looked to the past for its biggest community celebration—the annual Orange International Street Fair. First held on Labor Day weekend 1973, the idea came from old photos of a street fair held in downtown Orange in 1910. To recognize the many different ethnic groups that have contributed to the city's growth, the modern street fair was given an international twist. It was an immediate success. Some 50,000 people visited the 1973 street fair, eating their way through six different internationally themed streets—German, Mexican, Italian, Irish, Danish and all-American. By 1981, nineteen different nationalities were represented on fourteen different "streets," and an estimated 300,000 people attended the street fair. By 1990, that number had climbed to 400,000, and it hovers around that level to this day. Many local organizations now depend on the street fair for much of their annual income.

As the street fair grew, the old May Festival celebration faded away. The last parade was held in 1991. But at the same time, new traditions were being born. The community Christmas tree lighting ceremony and Candlelight Choir procession has been held in the Plaza Square since 1994, with a live orchestra and a combined choir of hundreds of singers from local churches and schools. To beat the Independence Day rush, the city launched a July 3rd Celebration at Fred Kelly Stadium in 1996 with music, food and fireworks. Since 1988, graduates of Orange High School have held an annual all-class reunion at Hart Park; three thousand alumni attended the first year. Neighborhood reunions have also been held in El Modena and the Cypress Barrio.

Into the Foothills

When the postwar boom hit Orange County, the most desirable land for subdivision was the flat coastal plain. Much of this area was planted to row crops rather than citrus, so it was easy for growers to simply not replant one year and the developers to build houses instead. This explains the explosive growth of towns like Garden Grove, Westminster and Costa Mesa in the early 1950s. Building in the foothills was more expensive, more time consuming and considered less profitable back then. But as the lowlands filled up, the foothill areas became some of the most valuable land in the county.

Tract Homes and Freeways

A nearly barren Panorama Heights rises above the Alpha-Beta Market at Chapman and Hewes in El Modena in 1966. Today, the market is an Albertsons and the hill is covered with homes. *Courtesy the Orange County Archives.*

By the mid-1960s, Orange had begun annexing into the Orange Park Acres area, in the foothills at the top of Peters Canyon, north of Chapman Avenue. Orange Park Acres had been launched by the Mead family in 1928 as a large-lot rural subdivision. The area grew slowly and, as late as the 1950s, still ran largely to citrus, avocados and chicken ranches.

As tract home subdivisions approached in the 1960s, Orange Park Acres explored incorporation as a separate city, hoping to do Villa Park one better by limiting homes to just one per acre. Petitions were submitted to LAFCO (the county's Local Agency Formation Commission) in 1965, but the larger landowners generally opposed the move. In the end, LAFCO turned them down, and the issue never came to a vote. Instead, residents turned to both the City of Orange and the County of Orange to try to restrain developers through planning and zoning laws.

The controversy over the 120-acre Mead Ranch in the early 1970s was typical. In 1972, the Broadmoor Corporation received tentative approval to build 167 homes and more than 300 condominiums at the northwest corner of Chapman and Newport, planning to annex the area to the city of Orange. Residents of Orange Park Acres sued and temporarily blocked the project.

Long negotiations with the city and the county resulted in new zoning rules and design standards to protect the area's rural character. The Broadmoor development—by then reduced to just 202 homes—finally opened in 1976.

Orange has continued to make annexations in the Orange Park Acres area, but the core of the community remains unincorporated county territory. The citrus groves and chicken ranches have been replaced by estate homes and horse ranches, and Orange Park Acres' identity remains strong.

The area south of Orange Park Acres, in upper Peters Canyon, remained undeveloped until the 1980s. This area was part of the vast Irvine Ranch. In the late 1970s, the Irvine Company approached the City of Orange with an eye to eventual annexation, but it was not until 1984 that the city approved the first development in the area, at the southeast corner of Chapman and Newport.

The Irvine Company dubbed the rolling grasslands Santiago Hills and built several residential tracts there in the second half of the 1980s. Other developers purchased land from the Irvine Company and launched their own developments nearby.

As construction increased, in 1989, the city approved its first East Orange General Plan, which envisioned development continuing well up into the Santa Ana Mountains to the east. The original plan called for twelve thousand homes in the area. In 2003, it was revised down to just four thousand homes to be built beyond the Eastern Transportation Corridor, going all the way out and around Irvine Lake.

New homes meant new schools for the area as well. Chapman Hills Elementary—Orange's first new school in a decade—opened in portable classrooms in 1989, and its distinctive campus was completed two years later. The student body increased in 2009 when the Orange Unified School District closed the historic Silverado Elementary School and began busing its students down to Chapman Hills.

East Orange is also home to Santiago Canyon College. It opened in 1985 as the Orange Campus of the Rancho Santiago Community College District, a branch of the old Santa Ana Junior College, which opened in 1915. In 1998, when the Orange Campus became a separate school under its own name, it already had some 9,200 students. The campus has expanded greatly since then, with two more buildings now under construction.

Parkland has also been preserved as the foothills fill with houses. The city of Orange has Santiago Hills Park, which opened in 1988. The county of Orange has Santiago Oaks Regional Park and the 360-acre Peters Canyon Regional Park, which surrounds Peters Canyon Reservoir (built by the Irvine Company in 1931).

Tract Homes and Freeways

Development in the northeastern corner of Orange, beyond Villa Park, began in the 1970s. The first phase of the Mabury Ranch, at Cannon Street and Serrano Avenue, opened in 1978. Unlike the cookie-cutter tract homes of the 1950s, the developers now hoped to craft neighborhoods, not just houses. "Here you will find a rare combination of land planning and architectural detailing that will enhance property values for years to come," they boasted. "There are landscaped street medians, impressive entry and masonry wall treatments, pedestrian, bicycle and equestrian trails. The homes are located on estate-size lots ranging in size from 8,000 to 20,000 square feet. There's room to stroll, to play to enjoy." Prices ranged from $115,000 to $190,000.

Farther up the hill, Orange and Anaheim meet at the ridgeline. Originally, there was a gentlemen's agreement between the two cities that each would stay on its side of the Santa Ana River, but in 1957, Anaheim jumped the river by annexing into Peralta Hills. After some squabbling, the cities agreed on a new dividing line along the top of the Bixby Hills. At that time, cattle

Serrano Heights, at the northeastern corner of Orange, joins Anaheim Hills at the ridgeline. Completed in 2007, this is the most recent large residential project in the city. *Photo by the author.*

still grazed across the hills on the 4,200-acre Nohl Ranch, but in 1971, the Nohl Ranch was sold for development, and Anaheim Hills was born.

On the Orange side of the hills, planning for the Serrano Heights tract began in 1984, but it was not until 1990 that the city approved the initial development plans. A lawsuit against the project soon followed, but it was settled a year later, just in time for the recession of the early '90s. By the time construction finally began in 1997, the property had passed through the hands of several developers. SunCal built the first 200 homes in Serrano Heights. Just below, Partridge Estates opened about that same time. Construction in Serrano Heights continued over the next decade, with the last tract completed in 2007, making a total of about 1,100 homes stretching across the hills.

Past, Present and Future

Looking back on the 140-year history of the city of Orange, it's clear that certain factors have influenced our development all along the way. And all of these factors are related; change any one of them, and you change the whole story.

Take water, for example. You don't have to live in Southern California very long to understand that water holds the key to almost everything that happens here. Indian villages, missions and rancho adobes were all located where water was easily available. A.B. Chapman could have started Orange anywhere on his thousands of acres of open land, but instead, he bought even more land so the center of town could be at a spot where he could easily supply irrigation water.

Controlling the local water supply was one of the main ways Chapman and his partners controlled early Orange. When local ranchers objected, they formed their own water company—the Santa Ana Valley Irrigation Company—to take charge of their own destiny. Later, as Orange grew, we turned to the Metropolitan Water District of Southern California to assure a steady supply of imported water for our growing community.

But Orange could not have been founded at all until after the breakup of the old Rancho Santiago de Santa Ana. When much of this area was controlled by just a few large landowners, there was no opportunity for growth, no way for small farmers or merchants to find a foothold.

Rich land and irrigation water made agriculture possible here, but the richest harvest would have been worthless without access to dependable

transportation. The combination of land, water and railroads made the citrus industry possible.

Throughout the years, new means of transportation have always brought new development with them, whether it was stagecoaches along the old El Camino Real, railroads, good roads, freeways or now toll roads. Yet improved transportation has proven to be a mixed blessing, making it easier for people to live in one town, work in another and shop in a third. Where, then, do their loyalties lie? And what of those long-distance commuters who spend two, three and even four or more hours just getting to and from work every day? What time do they have left for their families, much less their community?

Sadly, some of the other factors that helped shape our community seem to be gone for good. The First National Bank of Orange was a source of security, credit and—during the dark days of the Depression—even compassion. The old *Orange Daily News* helped to bind together the community with information and ideas for more than half a century. Now the major banks in town are all just part of a regional or national chain, with no deep ties to the community, and the weekly *Orange City News* is simply a satellite of the *Orange County Register*.

A real community is a community of common interests and ideals. There will be differences, of course, but people need to focus on the things we all share if we are all going to grow together. The city of Orange will continue to grow for many years to come. Newer, higher-density projects will fill in available land in the older parts of town, and there are thousands of acres of Irvine Company land to the east still waiting to be developed. Some plans would have the city of Orange extending all the way up and around Irvine Lake.

Yes, the city of Orange will continue to grow. The only question is—will our community grow with it? Can Orange retain that distinctive identity that sets it apart from the sea of suburbia that has washed over Orange County?

Only time will tell.

SELECTED BIBLIOGRAPHY

Armor, Alice. "Early History of Orange Is Recalled." *Orange Daily News*, October–November 1918.

Armor, Samuel, ed. *History of Orange County*, Los Angeles: Historic Record Co., 1911. Second edition, 1921.

Brigandi, Phil. *First Church: A 125th Anniversary History of the First United Methodist Church of Orange*. Orange, CA: First United Methodist Church, 1998.

———. *A New Creation. The Incorporation of the City of Orange, 1888*. Orange, CA: City of Orange Centennial Commission, Inc., 1988.

———. *Orange County Place Names A to Z*. San Diego, CA: Sunbelt Publications, Inc., 2006.

———. *Orange: The City 'Round the Plaza*. Encinitas, CA: Heritage Media Corp., 1997.

———. *"Out Among the Groves of Orange": A History of Orange Union High School, 1903–1953*. Orange, CA: Orange High All-Class Reunion Committee, 2003.

———, ed. *The Plaza: A Local Drama in Five Acts*. Orange, CA: Wrangler Press, 1982.

Cramer, Esther, et al. *A Hundred Years of Yesterdays: A Centennial History of the People of Orange County and Their Communities*. Santa Ana, CA: Orange County Centennial, Inc., 1988. Second edition, 2004.

Donaldson, Stephen E., and William A. Myers. *Rails Through the Orange Groves: A Centennial Look at the Railroads of Orange County, California*. 2 vols. Glendale, CA: Trans-Anglo Books, 1989–90.

Selected Bibliography

[Elliott, N.H.] *Orange, Cal. and Its Surroundings Illustrated and Described*. Oakland, CA: W.W. Elliott & Co., 1886. Repr. by the Friends of the Orange Public Library, 1975.

Friis, Leo J. *David Hewes, More Than the Golden Spike*. Santa Ana, CA: Friis-Pioneer Press, 1974.

———. *Orange County Through Four Centuries*. Santa Ana, CA: Pioneer Press, 1965.

Gardner, Margaret. "The Community of Orange." In *Orange County History Series*, vol. 2. Santa Ana, CA: Press of the Santa Ana High School and Junior College, 1932.

Gibson, Wayne Dell. *The Olive Mill: Orange County's Pioneer Industry*. Santa Ana, CA: Orange County Historical Society, 1975.

———. *Tomas Yorba's Santa Ana Viejo, 1769–1847*. Santa Ana, CA: Santa Ana College Foundation Press, 1976.

Meadows, Don. *A Friendly Community Near the Foothills*. Orange, CA: First National Bank of Orange County, 1973.

———. "Orange Roots." 1972–92. Unpublished manuscripts and notes, Don Meadows Collection, Department of Special Collections, UC–Irvine Libraries.

Mueller, Jane, ed. *Orange Community History Project*. 2 vols. Fullerton: California State University, Fullerton Oral History Program, 1978.

Oliver, Katherine. "Progress of Orange Told by Veteran Merchant." *Orange Daily News*, February 2, 1927.

Orange Community Historical Society. *Color It Orange, A Selection of Stories about the City of Orange*. Orange, CA: Orange Community Historical Society, 1993.

Orange Daily News, special editions: July 1914; April 1928; April 26, 1932; April 30, 1938; May 15, 1953; July 26, 1957.

Orange Post, special editions: July 1903; August 19, 1909; August 27, 1915.

Pleasants, Mrs. J.E. *History of Orange County, California*. 3 vols. Los Angeles: J.R. Finnell & Sons, 1931.

Sleeper, Jim. *Bears to Briquets: A History of Irvine Park, 1897–1997*. Trabuco Canyon: California Classics, 1987.

———. *Turn the Rascals Out! The Life and Times of Orange County's Fighting Editor Dan M. Baker*. Trabuco Canyon: California Classics, 1973.

Stephenson, Terry. *Caminos Viejos*. Santa Ana, CA: Press of the Santa Ana High School and Junior College, 1930.

Talbert, Thomas B., honorary ed. in chief. *The Historical Volume and Reference Works…Orange County*. 3 vols. Whittier, CA: Historical Publishers, 1963.

SELECTED BIBLIOGRAPHY

Thompson, Lena Mae. *Lena Mae Thompson, Interviewed by Phil Brigandi...1978.* Fullerton: Orange County Pioneer Council and California State University Fullerton Oral History Program, 1994.

Transcript on Appeal, The Anaheim Water Co., et al. vs. The Semi-Tropic Water Co., et al. 1883 (64 Cal 185).

Weimer, George. *George N. Weimer, Interviewed by Paul F. Clark...1979.* Fullerton: California State University, Fullerton Oral History Program, 1985.

Westfall, Douglas. *Prisoners of the Civil War: The Story of Two Americans.* Orange, CA: Paragon Agency, 2001.

Wheeler, Roy S. *One Hundred Years in Retrospect: Orange Grove Lodge No. 293 F. & A.M.* Fullerton, CA: Sultana Press, 1988.

[Wilson, John Albert.] 1880, *History of Los Angeles County, California.* Oakland, CA: Thompson & West, 1880. Repr. Howell-North, 1959.

Works Progress Administration. *Orange County Historical Research Project #3105—Pioneer Tales.* Typescript, 1936.

INDEX

A

Adams, Harry 74
Adams, M.V. 29
adobes 8, 9, 110
African Americans 67
agriculture 10, 19, 48, 54, 81, 84
Ainsworth Block 67
Ainsworth, Lewis 67
Allen, Glenn 93
American Fruit Growers 50
American Legion 77
Ames, Anselmo 40
Anaconda Wire & Cable 56, 99
Anaheim 22, 25, 40, 42, 45, 57, 89, 109
Anaheim Hills 9
Anaheim Vine Disease 20
Anaheim Water Company 21, 22
Anderson, J.W. 23
Andrus, C.B. 24
antique dealers 99
Anza, Juan Bautista 8
apricots 20, 55
Armor, Alice 25, 35, 64
Armor, Sam 43, 64, 67
Assistance League 74, 77

automobiles 61, 76
Autonetics 89
avocados 55

B

Bank of America 72
Bank of Italy 72
Bank of Orange 35, 73
Banning tract 15
Bibber, A.H. 75
Bitterbush Tract 85
Bixby Hills 109
Blasdale, William 42
Block at Orange, the 101, 102
boom of the 1880s 29, 31, 36, 43, 64
Boy Scout cabin 78
Boy Scouts 78
Bracero program 54, 84
Bradshaw, C.B. 69
Brewer, Harold 48
Brickyard, The 99
Broadmoor Corporation 107
Burnham estate 63
buses 35
business 18, 23, 67, 71, 76, 90, 99

INDEX

C

California Elementary School 97
California Fruit Growers Exchange 48
California Walnut Growers Association 55
California Wire & Cable Company 56
Cambridge Elementary School 97
Campbell Block 69
Campbell, C.B. 71
Campbell's Opera House 71, 75
Camp Commander 83
Camp Myford 78
Camp Osceola 77
Camp Rathke 83
Camp RoKiLi 78
Canal Street 16
Canyon High School 98
Carey Stationers 69
cattle ranching 8, 14
Center Street School 97, 98
Central Lemon 40, 50
Central Orange County YWCA 105
Chambers, Hod 59
Chapman, Alfred 15, 18, 21, 48
Chapman Avenue 33, 61, 104
Chapman College Chapel 45
Chapman Hills Elementary School 108
Chapman University 18, 45, 53, 56, 57, 98
Children's Hospital of Orange County 63
Chinatown 24
Christmas tree lighting ceremony and Candlelight Choir 106
Chubb, O.P. 42
churches 18, 40, 44, 55, 74, 78
citrus industry 48, 79, 81

citrus labels 52
City, The 73, 101
Civil War 16
Clark, Albert 17
Clemons, Fred 64
clubs and organizations 68, 71, 76
Colonial Theatre 71
commuter culture 102, 111
Consolidated Orange Growers 50
Cornet Store 69, 99
Costa Mesa 15
Costa Mesa Freeway. *See* Newport Freeway
Covenant Christian Church 45
Craemer, Justus 65
Crespí, Father Juan 8
crime 25
Crowder, Robert 23
Crowder's Store 23, 26
Cuddeback Building 23, 70
Culver, Charles 32, 42, 43
Cypress Street Barrio 54, 56, 106
Cypress Street School 96, 99

D

David Hewes Orange & Lemon Association 50
Delhi 55
Den'o'Sweets 72
Depot Park 31
Depression (1930s) 40, 71, 78, 82
Dittmer's Mission Pharmacy 69
domestic water 93
droughts 21

E

Eastern Star 76
Eastern Transportation Corridor (SR-241) 104
East Orange General Plan 108
Edwards Block 26, 69

INDEX

Edwards, E.E. 42
Edwards, N.T. 69, 79
Ehlen & Grote 71
Ehlen & Grote Block 70
Ehlen, P.W. 71
Eichler, Joseph 87
Eisenhower Park 21
El Camino Real 10, 17
Elks Lodge 68, 71, 77, 78
El Modena 39, 40, 50, 55, 57, 96, 106
 early descriptions 39
 naming 39
El Modena Friends Church 39
El Modena Grade 33, 59
El Modena High School 58, 98
El Modena Record 39, 63
El Modena School District 97
Eltiste, Michael 74
Epworth League 78

F

Fairbairn, Ranald 66
Fairhaven 87
Fairhills 87
Fairmeadow 87
fiestas 12
First Baptist Church 45
First Christian Church 44
First Commercial Bank of Orange 72
First Methodist Church 18, 23, 44
First National Bank of Olive 40, 79
First National Bank of Orange 74, 79, 111
First National Bank of Orange County 74
First Presbyterian Church 25, 44, 78
Fischer Bros. store 18, 71
flood (1938) 81
floods 81

Foothill Valencia Growers 50
Ford, Archie 67
Franzen family 73
Fred Kelly Stadium 58, 106
freeways 102, 111
freeze (1937) 81
Friedemann Building 71
Friedemann, Richard 71
Friendly Center 44, 55
Fullerton, James 64, 65

G

Garber, Harvey 39
Garden Grove 34, 101, 106
Garden Grove Freeway (SR-22) 103
Gardner family 25
Gardner, Henri 26, 42
Gardner Ranch 25
Germans 45
Girl Scout Hut 78
Girl Scouts 78
Glassell, Andrew 15, 21
Glassell Street 33, 104
Glassell, William 16, 17
gold rush 14
Good Roads Movement 61
Goon Gay 25
grain farming 19, 22
Grange 76
Grange Store 76
grapes 15, 19, 20, 39, 43
Great Western Cordage 56
Grijalva, Juan Pablo 8, 9
Grote, Fred 71
Grote, Henry 71
Gunther's Clothing 71

H

Hallman and Field 75
Handy Elementary School 97

119

Index

Harms Drug Store 71
Hart Park 36, 80
Hart, William, Jr. 66
Hart, William, Sr. 65, 66
Harwood, Nathan 15, 17
Heim Avenue 40
historic home tours 105
historic preservation 104
Hockaday & Phillips 70
Holy Family Catholic Church 45
homeless 79
Home Telephone Company 60
horse racing 12
hospitals 63
Hotel Rochester 33, 43
Hoyt house 8
Huff's Jewelry 70
Hurwitz & Hurwitz 67
Hurwitz, Mark 67
Hurwitz, Samuel 67

I

Immanuel Lutheran Church 46
Independent Order of Odd Fellows
 (IOOF) 68, 71, 76
Indian Guides 78
Indian Princesses 78
industry 55, 84, 89
International Marketland 101
irrigation 10, 16, 17, 18, 21, 110
Irvine Company 78, 108, 111
Irvine, James 14
Irvine Lake 108
Irvine, Myford 78
Irvine Park 44, 78, 83
Irvine Ranch 10, 108
Irvine Ranch Outdoor Education
 Center 78

J

Japanese 96
JCPenney 73, 99, 102
Jensen, N.F. 46
Job's Daughters 78
Jorn Building 69
Jorn, Carl 70
July 3rd Celebration 106
Junior Chamber of Commerce 77

K

Kelly, Fred 58
Kibby, Harold 97
Killefer Elementary School 96
Killefer Park 55
Kogler-Franzen Block 73
Kogler Hardware Company 73
Kogler, Henry 73
Kogler, Jacob 45
Kogler, Paul 73
Kogler, Will 73

L

land grants 9, 10
La Paloma 55
La Purisima Catholic Church 55
La Veta Elementary School 97
lemons 19
Lemon Street 34
Lemon, U.S. 64
Limestone Canyon 78
Lincoln School 96
Lions Club 77, 81
Local Agency Formation
 Commission (LAFCO) 107
Lockhart, T.J. 11
Long Beach earthquake 80, 97
Lost Valley Scout Reservation 78
Luna, Simon 54

INDEX

M

Mabury Ranch 109
MainPlace 102
Main Street 33, 61
Mall of Orange 101
malls 101
Maple Avenue School 45
Marie Callender's 99
Marsh's Drug Store 72
Martinez, Sal 51
Masonic Lodge 69, 72, 76
Masonic Temple 71
May Festival 81, 106
McAulay, Robert Burns 44
McClelland, Lee 40
McCormick, Paul 96
McFadden, James 42
McPherson 39, 40
McPherson brothers 19, 20, 39
McPherson Heights Citrus
 Association 50
Mead family 107
Meadows, Charles 65
Meadows, Don 17, 58, 64, 65
Mead Ranch 107
Mendez v. Westminster 96
Metrolink 100
Metropolitan Water District of
 Southern California (MWD)
 93, 110
Mexican Americans 44, 54, 81, 96
Mexican Independence Day 12
Meyers Millinery 67
Mission Clay Products 39, 99
Mission San Gabriel 8
Mission San Juan Capistrano 8
Moreno's Mexican Restaurant 39
Morgan, Walls & Clements 74
Mosbaugh, George 26
motion picture theatres 71, 74
Mountain View. *See* Villa Park

Municipal Water District of Orange
 County 93, 95
Mutual Orange Distributors 50

N

National Register of Historic Places
 105
natural disasters 80
New Deal 80
Newport Beach 22, 34, 38
Newport Freeway (SR-55) 102
newspapers 63, 75
Nohl Ranch 110
North Orange Christian Church
 40

O

Old Orange Antique Dealers
 Association 100
Old Towne Preservation
 Association 105
Old Towne Project 104
Olive 9, 19, 21, 31, 39, 57, 63
 early descriptions 39
Olive Elementary School 40, 80
Olive Fruit Company 50
Olive Garage 40
Olive Heights 39
Olive Heights Citrus Association
 50
Olive Hillside Groves 50
Olive Hotel 75
Olive Mill 22
Olive Post Office 40
Orana 61
Orange
 annexations 87, 90, 107
 city halls 23, 60, 70, 90, 94
 early descriptions 11, 17, 23, 29,
 47, 75
 founding 17

INDEX

incorporation 41
naming 18
politics 65, 80
population 23, 48, 88
redevelopment 102
Orange Building & Loan Association 74
Orange Camera 73
Orange city manager 93
Orange City News 67, 111
Orange City Water Company 60
Orange Commercial Club 71
Orange Community Chamber of Commerce 77
Orange Community Historical Society 104
Orange Community Welfare Board 79
Orange Cooperative Citrus Association 50
Orange County
 formation 42
 name 19
Orange County Animal Shelter 92
Orange County Fruit Exchange 43, 50
Orange County Health Camp 78
Orange County Hospital 92
Orange County Juvenile Hall 92
Orange County Library 92
Orange County Probation Department 92
Orange County Register 67
Orange County Transportation Authority 103
Orange Crush 103
Orange Daily News 65, 67, 75, 111
Orange Dummy 34
Orange Fire Department 60, 91
 Museum 106
 Station #2 91
 Station #8 91

Orange Freeway (SR-57) 103
Orange Grove Masonic Lodge. *See* Masonic Lodge
Orange Hardware 71
Orange High School. *See* Orange Union High School
Orange Hotel 23
Orange Intermediate School 59
Orange International Street Fair 106
Orange Lionettes 81
Orange Mercantile Association 77
Orange Merchants & Manufacturers Association 77
Orange Mutual Citrus Association 50
Orange News 64, 65
Orange Paint Store 73
Orange Park Acres 107
Orange Plunge 82
Orange Police Department 90
Orange Post 64, 65, 66
Orange Post Office 18
Orange Public Library 23, 29, 36, 60, 91, 104
 El Modena Branch 91
 Taft Branch 91
oranges 19, 20, 48
Orange Theatre 74
Orange Tribune 29, 63
Orange Unified School District 97, 99
Orange Union High School 57, 80, 81, 97, 106
 Dutch-Irish Days 59
 O-Day 59
 publications 58
 sports 58
Orange Union High School District 57, 97
Orange Water Department 60

INDEX

Orange Youth Employment Service 77
Order of DeMolay 78
Order of Rainbow for Girls 78

P

Pacific Electric Railway 34
Pacific Telephone & Telegraph 60
packinghouses 40, 49, 50, 52, 55
Palmiter, Amy 66
Palmyra Elementary School 97
Palmyra Hotel 32
Parker, Alexander 44
Parker family 11
Parker, Joshua 11
parking meters and parking lots 92
Partridge Estates 110
Pearson, Marcus 44
Peralta family 9, 14
Peralta Hills 109
Peralta, Juan Pablo 7, 9
Peralta, Rafael 7
Peralta, Ramon 9
Peters Canyon 78, 96, 107, 108
Peters Canyon Regional Park 108
Peters Canyon Reservoir 83, 108
Pico House 37
Pitcher, Alice 105
Pitcher, Laurence 105
Pitcher Park 105
Pixley, D.C. 23, 69, 73
Pixley Furniture Store 69
Pixley, Walter 69
Plaza Alley 71
Plaza, A Local Drama in Five Acts, The 35, 36
Plaza Barber Shop 67
Plaza fountain 35
Plaza Park 35, 104
Plaza Park (Orange and Washington) 75
Plaza Square 17, 35, 47, 75, 104

Plaza Theatre 71
Portolá Expedition 7
Portolá, Juan Gaspar de 7
postwar boom 85, 89, 94, 106
Potter, N.U. 69
Preservation Orange 104
Prohibition 42
Pumpkinville 20
Putnam, Mr. 15

Q

Quakers (Friends Church) 39
Quick Decline 53

R

Radio Shack 69
railroads 22, 30, 31, 40, 100, 111
raisins 19
Rancho Lomas de Santiago 10
ranchos 9, 10, 14
Rancho Santiago Community College District 108
Rancho Santiago de Santa Ana 7, 9, 14, 15, 17, 22, 110
Rathke, George 83
real estate auctions 29, 31, 37
Rebekahs 76
Red Fox Orchards 50
Red Hill Avenue 9
Richland Farm Lots 16
Richland, name change 18
Richland Walnut Association 55
Riverside Freeway (SR-91) 103
Rodriguez adobe 11
Roosevelt School 96
Rosenberg Brothers 55
Rotary Club 77
Rusk, Sam 26
RWB Party Props 50

INDEX

S

saloons 41, 42
Santa Ana 18, 21, 22, 25, 34, 42, 43, 57, 73
Santa Ana Abajo 10
Santa Ana Canyon 9, 21, 22, 31, 103
Santa Ana Freeway (I-5) 61, 102
Santa Ana Mountains 8
Santa Ana Register. See Orange County Register
Santa Ana River 10, 16, 21, 22, 81, 93, 109
Santa Ana Valley Irrigation Company 21, 22, 24, 65, 110
Santa Ana winds 19
Santa Fe depot 31, 82, 100
Santa Fe Railroad 30, 40
Santiago Canyon College 108
Santiago Council (Girl Scouts) 78
Santiago Creek 8, 34, 78, 79
Santiago Hills 108
Santiago Hills Park 108
Santiago Oaks Regional Park 78, 108
Santiago Orange Growers Association 43, 50, 53, 99
SAVI. *See* Santa Ana Valley Irrigation Co.
school desegregation 96
schools 45, 57, 96
 first 18
Sears 101
semitropical fruit 19
Semi-Tropic Water Company 21
Serra, Father Junípero 8
Serrano Heights 110
sewers 60, 95
Shaffer, P.J. 17, 42
sheep ranching 11
Silverado 57

Silverado Elementary School 108
Simon's Drug Store 72
Sisters of St. Joseph 61
Smith, A.R. 71
Smith & Grote Building 71
smudge pots 53
Son Light Christian Center 74
Southern Baptist Church 45
Southern California Edison 67
Southern Pacific 22, 30, 40
Spurgeon, William 17, 42
Stadium Drive-In 102
Stadium Promenade 102
stagecoaches 17, 22
state highway 61
Stearns, Abel 14, 15
Stephenson, Terry 29
St. James 40
St. John's Lutheran Church 45
St. John's Lutheran School 45, 59
St. Joseph Health System 63
St. Joseph Hospital 61
St. Paul's Lutheran Church 40
streetcars 33, 39
strikes 81
subdivisions 31, 53, 94, 109
SunCal 110
Sunkist 48
Sunset Telephone & Telegraph 60
Sycamore Elementary School 97

T

Taft Avenue 55
Taft, Charles 55
telephones 60
temperance 41, 76
Theo Lacy Jail 92
Thirtieth Field Artillery Battalion 82
Thompson, Lena Mae 47
toll roads 103
Tom Thumb Hill 33, 39

INDEX

Town & Country 99
Townsend, Verrill 59
Trabuco Creek 8
transportation 22, 102
Treasury store 102
Trinity Episcopal Church 45
Tubbs Cordage Company 56
TusKatella Center 99
Tustin 15, 18, 21, 40, 57
Tustin Avenue 74, 99, 102
Tustin, Columbus 15, 18
Tustin Street. *See* Tustin Avenue
20-30 Club 77

U

UCI Medical Center 63, 92
Union Bank 99
unions 81

V

Valencia oranges 48, 50, 51, 81
vegetables 19, 25
Veterans of Foreign Wars 71, 77
Village at Orange, the 101
Villa Park 40, 57, 90
Villa Park Congregational Church 40
Villa Park High School 98
Villa Park Orchards 40, 48, 50, 53
Voigt, Charles 67

W

Walker Hall 45
Walmart 101
walnuts 20, 55, 96
Walther League 78
Walton, Nita 58
Wanda 40
Ward, Bill 63
water. *See* irrigation
Watson, Kellar, Sr. 24, 68

Watson's Drug Store 24, 68
Weaver's Book Store 69
Weimer, George 85, 88, 92, 93
Wells Fargo 74
Western Auto 70, 73
West Orange 10, 20, 22
West Orange School 44
White, Stewart 96
winemaking 19
Woman's Christian Temperance Union (WCTU) 76
Woman's Club of Orange 77
Woodruff, Leslie 64
Woods Dry Goods 75
Woods, George 75
World War I 46
World War II 54, 59, 82
Wright, George 65

Y

Yarnell tract 29
Yick Sing 25
Yorba, Bernardo 10, 22
Yorba family 9, 14
Yorba, José Antonio, I 7, 9
Yorba, José Antonio, II 7, 9
Yorba Linda 10, 34
Yorba, Ramon 13
Yorba, Teodosio 7, 10
Yorba, Tomas 7
Young, Joseph 19, 20
Young Men's Christian Association (YMCA) 77
Young Women's Christian Association (YWCA) 77

ABOUT THE AUTHOR

Phil Brigandi has been researching and writing local history since 1975. A native of Orange, he has always had a special interest in the history of his hometown. He joined the Board of Directors of the Orange Community Historical Society at age eighteen and published his first book on Orange five years later. He soon broadened his interest to include the rest of Orange County and served as county archivist from 2003 to 2008. He is the author of more than twenty books and hundreds of articles.

Visit us at
www.historypress.net